COLOUR

FOR WEB DESIGN

CAMERON CHAPMAN

ILEX

COLOUR FOR WEB DESIGN

First published in the United Kingdom in 2014 by
ILEX
210 High Street
Lewes
East Sussex
BN7 2NS

Distributed worldwide (except North America) by
Thames & Hudson Ltd.,
181A High Holborn, London WC1V 7QX,
United Kingdom

Copyright © 2014 The Ilex Press Limited

Publisher: Alastair Campbell
Creative Director: James Hollywell
Managing Editor: Nick Jones
Senior Editor: Ellie Wilson
Commissioning Editor: Zara Larcombe
Art Director: Julie Weir
Designer: Simon Goggin

British Library Cataloguing-in-Publication Data

A catalogue record for this book is available from the British
Library.

ISBN: 978-1-78157-142-2

Printed and bound in China

Colour Origination by Ivy Press Reprographics

10 9 8 7 6 5 4 3 2 1

contents

introduction

Color is one of the most powerful sensory stimuli we encounter on a daily basis. It has the ability to lift our mood, or lower it, the power to suppress our appetites, or stimulate them, and it can have restorative, calming, and even healing powers.

For those of us designing for the web, to ignore the power of color in our designs is to do a great disservice to our clients and our projects. Color is often the first thing that's noticed in a design or a website, and can have the most immediate impact on your visitors. If your color scheme is giving them the wrong impression, then that can be hard to overcome.

My own love affair with color began at a very young age. It might have been due to the DUPLO blocks (like giant LEGO) I loved to play with, or maybe the box of 96 Crayola crayons I used on an almost daily basis. Whatever it was, I had a love of color from the start.

Color was further integrated into my life through arts and crafts projects. As I grew older, I educated myself on color theory. I had very few formal art courses growing up, so most of what I learned was through books. My mother's books on quilting and fiber arts were invaluable in these early lessons, as was the public library.

In my late teens I decided design was where I really wanted to make a career. I knew that my strength lay in the use of color over other design skills, and so I continued to refine my craft through both education and trial-and-error.

Formal color theory has a rather long history, beginning around 1435 when it was first written about by Leon Battista Alberti. Leonardo da Vinci wrote about color theory in his journals 55 years later. The theory was further expanded upon in Sir Isaac Newton's book Opticks, published in 1704.

Eighteenth century color theory was based on subtractive color systems, with red, blue, and yellow as primary colors. During this time, the sensory and psychological influences of color were focused upon.

By the end of the nineteenth century, color theory began to focus on additive color systems, with red, green, and blue as the primary colors.

Then in the twentieth century, synthetic pigments were created that allowed for better saturation in color mixes. Primary colors with these new pigments became cyan, yellow, and magenta (with black, the "key" color, often included as well, making up the commonly used CMYK scheme). Secondary colors in this instance became red (when yellow and magenta are mixed), green (when yellow and cyan are mixed), and blue (when cyan and magenta are mixed).

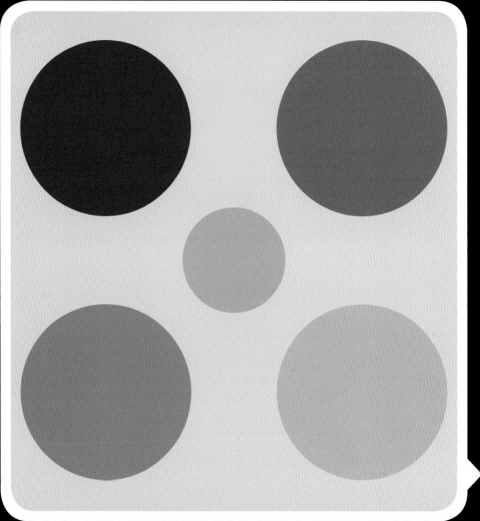

Even before formal color theory was developed, human beings were using color in art and craft. In fact, color has been used in handicrafts produced by people since ancient times. Early pigments were made by mixing colors found in the soil with water, as well as from plant matter.

Early art and the colors used were closely tied to religion in ancient times, in Ancient Egypt, Mesopotamia, and the Far East. It wasn't until Ancient Crete that art was created for art's sake, rather than in relation to religion, and color was no longer used simply for its religious significance.

Color, of course, has always played a significant role in art and design. Design for the web is no different. There are challenges that are present on the web that don't exist or are much less troublesome in the analog world. Those challenges will be covered later in the book.

This book starts with an overview of the basics of color theory, first with the terminology used in formal and scientific discussions of color. A sound grasp of these terms is key if you want to thoroughly understand the principles behind color theory at a professional level.

The meanings behind various colors are also discussed, as they're vital to using color to create the psychological impression your project needs. After all, you wouldn't want to create a website for a children's toy company that uses colors that evoke feelings of dread or anger.

A comprehensive look at traditional color scheme patterns is also key to learning to create your own palettes. There are particular ways of combining colors that are pleasing to the eye, create good contrast, and result in specific psychological responses.

Once you have the basics down, we'll move on to putting together your own color palette. This covers the basic parts of a color scheme, including base colors, main colors, and accent colors, as well as examples of each in practice. And beyond knowing the parts of a color scheme, you need to know how to actually create your own, both from scratch and by pulling colors from a photo or an existing color palette (such as when taking inspiration from another website or design). It's important to know how to tailor a color scheme to the purpose of your site, as well as how to best use tints, shades, and tones. Achieving proper balance in your color schemes is also covered.

From here the book discusses color conventions in web design, including industry standards for various types of businesses and associations built on popular brands and websites. And before we're done, we'll talk specifically about applying color to your designs, including how to work within conventions and when to break with tradition.

By the time you've finished reading, you'll have a strong grasp of how to use color in designs, why certain colors work together, and how to use color to get the best results for your clients.

... that you can turn into sites like

1

TERMINOLOGY

While many designers are familiar with the terminology surrounding color theory, there is plenty of room for confusion between the technical and more common definitions of many terms. This section aims to clarify these terms before we move on to the real "meat" of color theory.

commonly used terms in color theory

There are a huge number of terms relative to color theory that the average person isn't necessarily familiar with. Some terms are often used incorrectly (such as shade or tone), while others are rarely used at all by laymen (such as hue).

Before we embark on a professional discussion of color theory, it's important that we define the terms being used so that there's no confusion later on. For example, when I use the term "shade" later in the book, I'm talking about a very specific quality of color. By contrast, in everyday language "shade" is used much more loosely and often in place of the words "tone" or "tint."

To that end, the following glossary has been placed at the front of the book instead of at the back. Even if you're familiar with technical color theory terms, it's still a good idea to familiarize yourself with the definitions here as they'll be used in this particular book, to minimize confusion later on. And it's especially important if you're not already up to speed on color terminology.

Achromatic: Achromatic literally means "without color." They are hues that have zero perceived saturation—white, black, and gray.

Achromatic
White, black, and gray have no saturation or chroma.

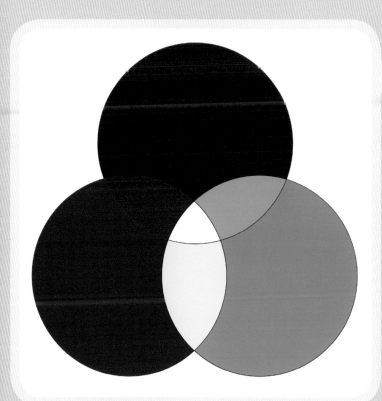

Additive color system: An additive color system is in reference to colors produced by light directly, such as a computer monitor. Primary colors in an additive color system are red, green (instead of yellow), and blue. When the primary colors in an additive color system are combined, you get white (as white is a combination of all the wavelengths of light).

Assimilation: Assimilation refers to when a color is perceived as more like the colors surrounding it than if it was viewed in isolation. For example, when yellow is viewed directly next to green, it may appear to have a greenish tint, while when viewed in isolation, it would appear purely yellow. The same type of effect is achieved when chromatic hues, like red or green, are placed next to black or white. Next to black they'll appear darker; next to white they'll appear lighter.

Balance: Balance refers to a state of equilibrium among elements in a composition. One of the key influencers of balance is the use of color in a design.

Basic color terms: There are 11 color names that are found in most fully developed languages around the world. These basic color terms, in English, are: black, white, gray, green, yellow, blue, red, orange, purple, pink, and brown.

Binary hue: A binary hue is created when two unique hues are combined. Purple, for example, is a binary hue created by the unique hues red and blue. In subtractive color systems, green is a binary hue created by mixing the unique hues yellow and blue. In additive color systems, yellow is a binary hue created by mixing the unique hues green and red.

Chroma: A hue's chroma is, in the simplest terms, how "pure" it is. This is directly influenced by the wavelengths of the hue. For example, gray has a very low chroma (because it is a mixture of wavelengths of light that comprise other pure hues), while red or yellow have very high chromas (because they're made up of a single wavelength of light). High-chroma hues are vivid, while low-chroma hues are dull. "Constant chroma" hues lie somewhere in the middle, and are often still vibrant to the eye while lacking the purity of high-chroma hues.

Color: Color is commonly used in reference to the technical term "hue." However, color is technically a combination of hue, lightness, and saturation. Additionally, color is often used colloquially in reference to chromatic hues (color vs. black-and-white photos).

Color perception: Color perception is a subjective impression of color, influenced by the situation in which the color is observed and the mental interpretation of the observer. This subjectivity is why when two people are asked what color something is, they often give slightly different answers, and why the same color in two different environments may be perceived to be different colors. It is closely related to assimilation in color theory.

Color scheme: A color scheme is an orderly selection of colors based on their relationships in the color wheel. There are a number of different types of color schemes, though they can be broadly categorized as monochromatic, analogous, and complementary.

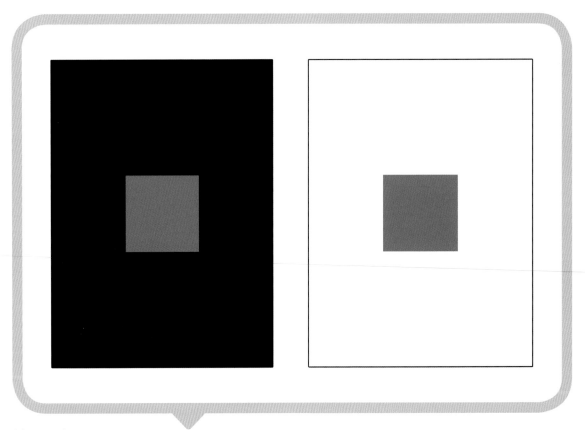

Color perception
This image is a great example of how color perception works. Notice how the gray square appears lighter when surrounded by black and darker when surrounded by white.

Color wheel: The color wheel is a circular arrangement of the color spectrum. They commonly appear either as a gradient covering the entire spectrum, or as a pie-chart-type diagram, with primary, secondary, and tertiary colors represented.

Complementary colors: There are two definitions for this. One is technical: two colors that produce a neutral gray (in paint or pigment) or white (in terms of light) when combined. The other definition of "complementary," and the one commonly used by the layman, is simply two or more colors that "go together." In this book, the first definition is the one that will be used.

Contrast: Contrast refers to the difference between two or more colors. In technical terms, contrast is the difference in luminance or color between two items. In layman's terms, it's what makes one element stand out from another element. High contrast means a big difference in either luminance (light blue vs. dark blue) or color (blue vs. orange). Low contrast means much more similarity between either luminance (navy blue vs. dark blue) or color (yellow vs. yellow-orange).

Color wheel
The traditional color wheel can come in many forms. This one more clearly delineates between primary, secondary, and tertiary colors. Other versions show each color with equal emphasis, or use a spectrum without clearly delineating individual colors.

Complementary colors
Blue and orange balloons are a perfect example of complementary colors.

Contrast
Red and green are located directly
opposite each other on the color wheel.

Dominance
The bright red-orange accents on this
wireframe clearly indicate some elements
are more important than others.

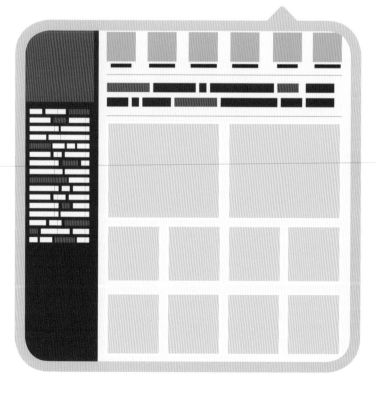

Dominance: Dominance refers to one item in a composition
being of greater visual importance than the other elements.
Color is a key determinant in dominance.

Hue: Hue is most often what we mean when we refer
to what color something is. Terms like yellow, orange,
or fuchsia are all in reference to the hue of something.
In technical terms, the hue is determined by the dominant
wavelength of the visible light reflected from a surface
(or emitted by a light source). For the purposes of this
book, hue and color will often be used interchangeably.

Key: Key refers to the dominant value relationship in a
picture or design. High-key compositions include medium
to light colors. Low-key compositions include dark to
medium colors. A composition that includes the full
spectrum of light to dark colors is called full contrast.

Limited palette: A limited palette refers to a small
number of colors used in a design or artwork.

Luminance: Luminance is the "lightness" of a hue. While it is similar to value, it's calculated with a different equation. Luminance varies greatly between different pure hues on the color wheel. Yellow, for example, has a luminance value of 94% in HSL color space, while blue has a luminance value of only 44%. An interesting aside: when saturation is decreased in any pure hue, it has a varying effect on the luminance of that hue. If the hue had a luminance value above 50%, then the luminance will decrease. However, if the luminance was already below 50%, then it will increase as the saturation decreases.

Monochromatic: Monochromatic color schemes are those that are made up of hues that have the same or very similar wavelengths (such as red and pink, or bright blue and navy blue).

Opacity: Opacity is simply the covering power of an element. Lowering the opacity of a color allows the color underneath it to show through, thereby changing the properties of the overlaying color. For example, red at 50% opacity over black will create a darker shade of red, while over white it would create a lighter tint.

Palette: A palette is simply a set of colors selected for use in a design or artwork. Unlike a color scheme, a palette does not have to rely on the relationships between colors on the color wheel.

Primary colors: Primary colors are colors that cannot be created by combining two or more other colors. In an additive color system, primary colors include red, green, and blue (RGB). In a subtractive color system, primary colors include red, yellow, and blue (RYB).

Saturation: Saturation is the level of intensity of a color in a given environment. A color lacking in strong chromatic content is "unsaturated" while a saturated color would be much stronger (like pure red or blue). But saturation is dependent on the lighting conditions surrounding the color. A color will look very different in bright sunlight than it will in dim candlelight.

Opacity
This image clearly shows the spectrum of opacity, from fully opaque to fully transparent.

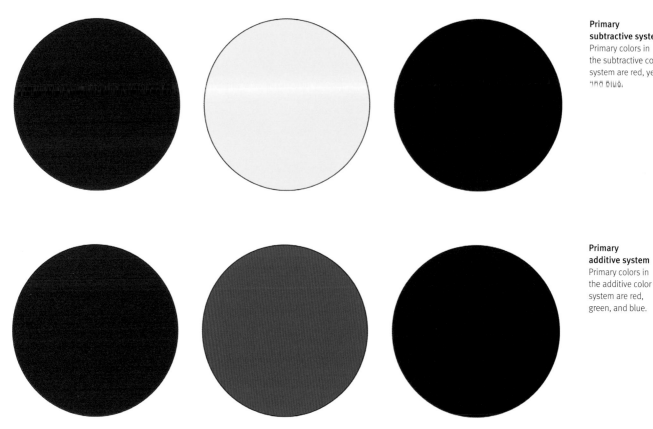

Secondary colors: Secondary colors are created when two primary colors are combined. In additive color systems that use RGB primary colors, the secondary colors are purple, orange, and yellow. In subtractive color systems that use RYB primary colors, the secondary colors are green, orange, and purple.

Shade: A shade is achieved by adding black to any pure hue, making it darker. For example, maroon is a shade of red and brown is a shade of orange.

Spatial contrast: Spatial contrast (sometimes just referred to as "contrast") is the difference in the visual property between adjacent areas of a scene (white shapes on a black background would have high spatial contrast). Contrast is very important in design, as it is key in differentiating one element from another.

Subtractive color system: A subtractive color system is in reference to things like paint or pigments, materials that absorb and reflect different wavelengths of light. The primary colors in a subtractive color system are either red, yellow, and blue (the primary colors most of us are taught in school); or cyan, magenta, and yellow (which are used by printers, along with a key color—generally black—to create the various secondary and tertiary colors). When primary colors in a subtractive color system are combined, you get gray or brown (depending on the ratios).

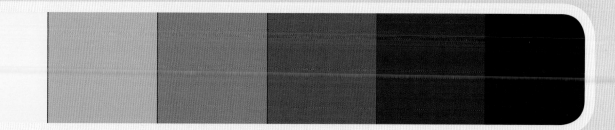

Shade
Adding black to yellow creates a variety of shades, while also lowering the intensity of the pure hue.

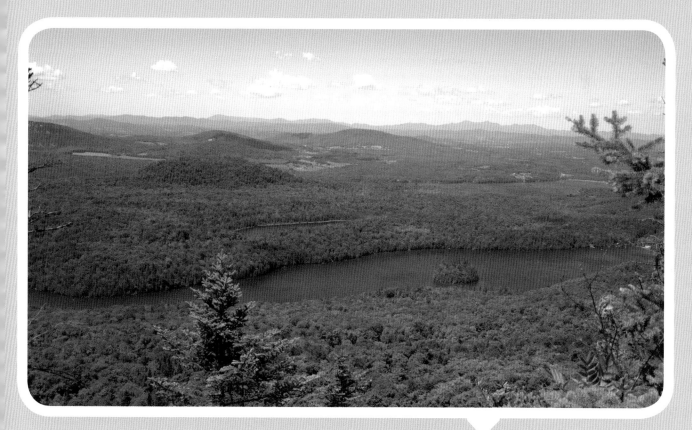

Saturation
This photo shows the range of saturation, from completely desaturated (grayscale) to saturated (full color).

Successive contrast: Successive contrast is the effect a previously viewed color has on the appearance of the currently viewed color. This is what creates an afterimage after staring at a particular scene for a period of time.

Temperature: Temperature refers to the relative warmness or coolness of a color. A color's temperature has a direct impact on its meaning, intensity in a composition, and other visual attributes.

Tertiary colors: Tertiary colors are created by combining primary and secondary colors in a color system. They include colors like blue-green, red-purple, orange-yellow, and yellow-green, among others.

Tint: A tint is achieved by adding white to any pure hue, thereby lightening it. Pink is a tint of red.

Tone: A tone is achieved by adding gray to any pure hue. Slate blue would be a tone of blue. Tones can either be lighter or darker than the original pure hue, depending on the lightness of the gray that is added to the hue. Tones can also be close in intensity to their pure counterparts, or barely distinguishable from pure gray.

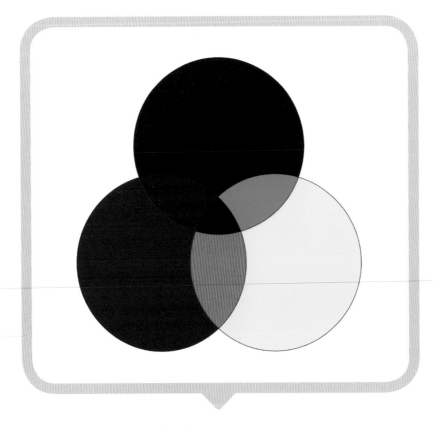

Subtractive color system
This image shows how primary hues combine in a subtractive color system to create secondary colors.

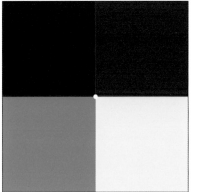

Successive contrast
Stare at the image on the left for fifteen or twenty seconds, and then look at the black dot on the right. You should see colors that are the opposite of the colors on the left (yellow and green on top, with red and blue on the bottom).

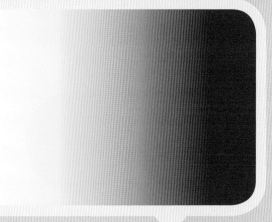

Temperature
The color temperature scale is generally represented with a limited color palette, with white separating the cool and warm hues. It's more commonly used with additive color systems, and particularly in photography to measure the quality of light.

Unique hue: A unique hue is perceptually unmixed. Unique hues include red, blue, yellow, and green (yellow and green are both included, though yellow is only unique in subtractive systems and green is only unique in additive systems). All binary hues are created by combining unique hues.

Value: Value is how light or dark a hue is; in other words, its "brightness." Value is determined by how close a hue is to white. Value has a direct influence on the contrast of an image. Values that are close together have low contrast and blend together to an extent. Values that contrast will separate objects in space, making some stand out from the others. These are constant whether the hues are

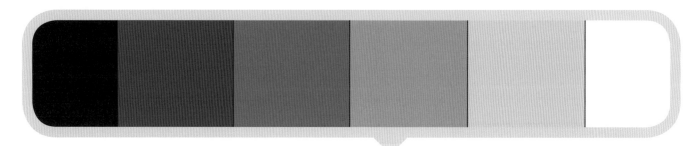

Tint
Adding white to blue creates a variety of lighter tints, also making the hue less intense.

Tone
Adding gray to green mutes the hue, as well as sometimes giving it a slightly darker appearance.

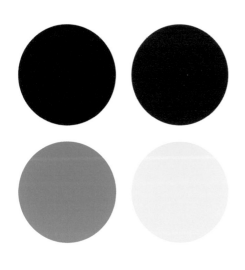

Unique hue
Blue and red are always unique hues, regardless of the color system used, while green and yellow are considered unique in additive and subtractive color systems, respectively.

chromatic or achromatic. Gradation of value, rather than contrast, implies a surface with mass and contour (such as shadowing in a sketch of a flower).

Visible spectrum: The visible spectrum refers to the light (electromagnetic radiation, if you want to get really technical about it) wavelengths that are visible to the human eye, ranging from about 400 to 700 nanometers. The visible spectrum is particularly well-illustrated by rainbows, which split and reflect white light into all of the colors visible to the human eye.

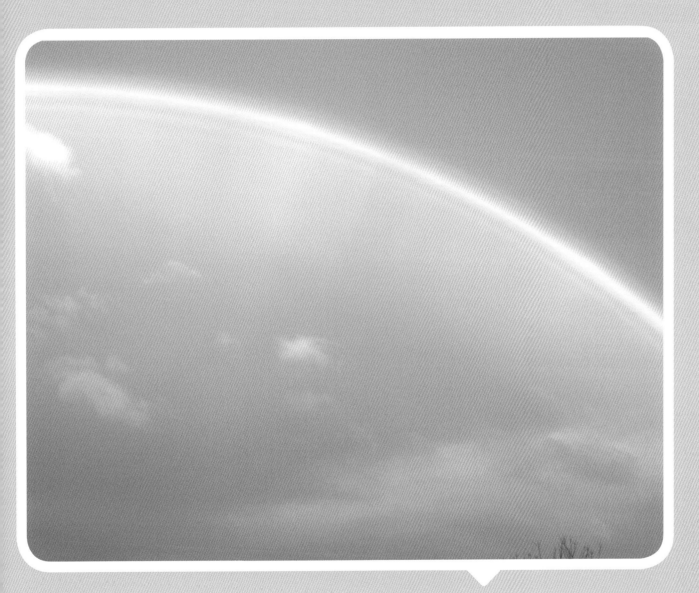

Visible spectrum
This rainbow is an excellent example of the visible spectrum of light.

Understanding the various color groups and how colors are classified within them is a vital first step toward creating your own color palettes. Here we'll break down the different types of groups and look at which colors fall into each.

how color
is classified

There are two different ways we can classify colors by group. The first is whether they are primary, secondary, or tertiary colors. In a subtractive color system, primary colors include red, yellow, and blue. Secondary colors include violet, green, and orange. Tertiary colors include red-orange, red-violet, blue-violet, blue-green, yellow-green, and yellow-orange.

The second way is by whether they are warm, cool, or neutral. Warm colors include red, orange, and yellow. Cool colors include violet, blue, and green. Neutral colors include white, black, gray, brown, and beige.

warm

What feelings do warm colors evoke?
Warm colors are called "warm" for a reason. Think of the way you feel on a summer's day with the sun shining down on you. Or the way you feel sitting in front of a roaring fire. These are the same feelings that warm colors evoke.

In general, warm colors are considered to be energetic and active. They're inviting, though they can also be intense. These colors often evoke a very positive feeling, though a lot of that depends on how they're used.

Warm colors also give the impression of advancing in space.

Warm
The spectrum of primary and secondary warm colors, from yellow to red.

Cool
The spectrum
of primary and
secondary cool
colors, from
purple to green.

cool

What feelings do cool colors evoke?

Think of the way you feel when looking out over the ocean or a lake, or at a forest or field. Think of the way you feel when you see distant mountain ranges appearing in muted shades of blue and purple. If you're like most people, these scenes probably make you feel calm and relaxed.

Cool colors are often perceived as more sedate than warm colors. They're also generally perceived as darker. They can be inviting, though they can also be more imposing than warm colors.

Cool colors appear to be receding in space, the opposite of warm colors.

A note about tertiary colors

Primary and secondary colors fit neatly into the categories of "warm" or "cool." Tertiary colors are also classified as either warm or cool, but the lines are a bit more blurry. In technical terms, the color wheel is divided between green (cool) and yellow-green (warm), and between red-purple (cool) and red (warm).

But in reality, yellow-green shares many characteristics with cool colors (despite the fact that it is made up of a higher percentage of yellow in relation to green), and red-purple shares many characteristics with warm colors (which makes sense, as it has a higher ratio of red to blue, since purple is already a mixture of the two colors).

How they are perceived is largely dependent on the colors they are surrounded by. For example, red-purple used in a color palette that includes red-orange and orange is going to appear much warmer than if it's included in a palette along with purple and blue-purple, where it would appear cooler.

neutral

What feelings do neutral colors evoke?

There are five neutral colors: black, white, gray, brown, and beige. These colors are considered neutral because they tend to work well with all other colors and often can be influenced by the colors surrounding them. "Neutral" is a bit of a misnomer when it comes to meanings, though. Each neutral color has its own distinct associations.

Think of the associations you have when staring into the darkness of night, or at a freshly laundered white duvet, or at brown dirt in a garden to get a sense of what these neutral colors might mean and the feelings they might evoke.

Neutral
The neutral spectrum, from black to white and brown to beige.

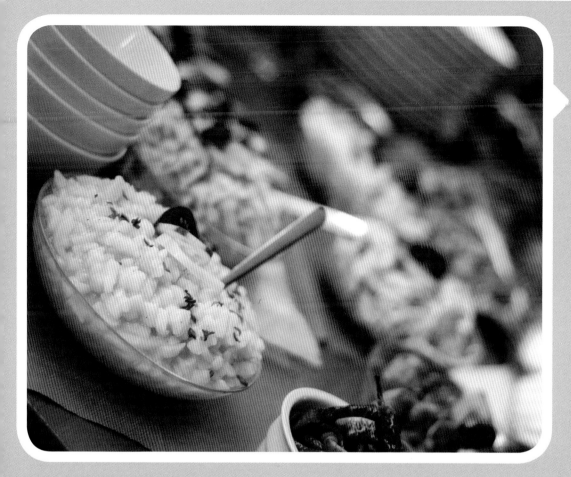

Tone
Notice how the nearly pure red and green hues have a much stronger impact than the more washed out yellow and green tints they appear next to.

Impact
By contrast, notice how the nearly pure blues, yellows, and oranges in this image compete for attention and all have a strong impact.

influence of tone, tint, and shade on meaning

The addition of gray, white, or black to any pure hue can have a huge degree of influence on the meaning of a color.

Tones are generally more muted, which means their influence on human psychology is also generally more muted.

Tints of a particular hue may take on more positive attributes than shades of the same color, which may be associated with the darker aspects of a hue's meaning. For example, pink is generally associated with the romantic characteristics of red, while dark red is more likely to be associated with connotations of anger.

3

COLOR MEANINGS

The meanings behind the various colors have a huge impact on how these colors are perceived in your designs. Understanding what colors mean, as well as how their associations can be affected by outside influences, is crucial.

the emotional effect of color

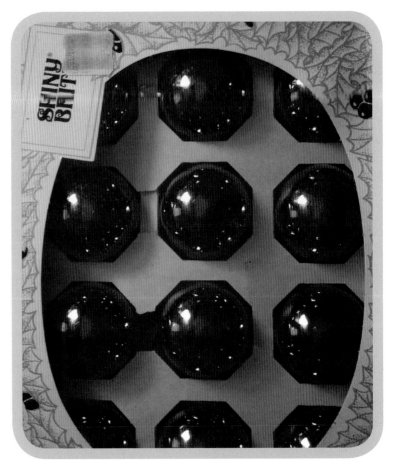

red

Red has a lot of very strong associations in our daily lives. It's tied to certain holidays, like Valentine's Day and Christmas. It's commonly seen in fall leaves in temperate climates, and elsewhere in nature—like male cardinals or tropical fauna and flora. And, of course, it's also associated with danger or strong warnings.

Red, a primary color, is associated with passion and love. But it's also associated with danger, anger, and violence. Both of these associations are likely tied back to the fact that red is the color of blood. Optimism and dynamic energy are associated with red, as are aggression and intensity.

Psychologically, red can stimulate brain wave activity, increase heart rate, and increase blood pressure. Astrologically, red is associated with Gemini. Red roses are associated with love and respect.

Tones, tints, and shades of red
Burgundy is associated with vigor, richness, refinement, leadership, and maturity, along with luxury.

Reddish-brown is associated with autumn and the harvest.

Dark red is associated with longing, rage, anger, malice, and wrath. It is also associated with leadership, willpower, courage, and vigor.

Light red is associated with sexuality and passion, as well as joy, sensitivity, and love.

Pink is tied to friendship, romance, and love, as well as femininity and passiveness. It is the color of unconditional love and understanding, as well as a sign of hope. Due to aggressive marketing, pink (and pink ribbons) are strongly associated with breast cancer awareness. Pink is also closely associated with baby girls.

Light pink is associated with softness, sweetness, compassion, tenderness, and delicacy, but like pink and red, it is also associated with love and romance.

Fuchsia is sensual and hot, as well as energetic, fun, and feminine. It's very popular for packaging and marketing aimed at women.

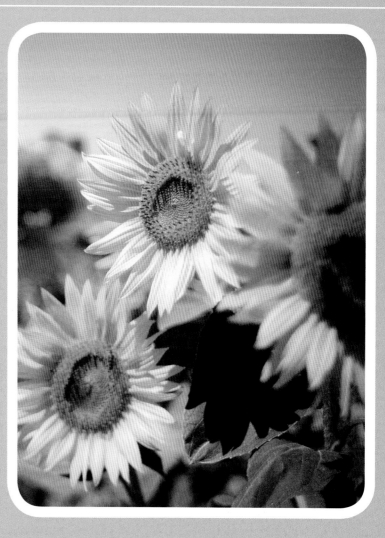

yellow

Yellow is one of the most prevalent colors in nature. It is the visible color of the sun, first and foremost, and is an incredibly warm color because of this. It's also commonly seen in flora and fauna. In the manmade world, yellow is representative of caution, though not as strongly as orange or red.

Yellow, also a primary color, is associated with happiness and joy. It's also tied to intellect, idealism, philosophy, imagination, action, and energy. It's the color of sunshine and summer, of youth and hope. On the flipside, yellow can be associated with cowardice (calling someone "yellow" is equivalent to calling them a coward), though this is a relatively new meaning.

Yellow can energize and relieve depression in a person's surroundings. It also improves memory and stimulates appetite. For that reason, it can be a great choice for restaurant branding or other food-related businesses. Yellow roses are associated with friendship and joy, rather than romance. Astrologically, yellow is often tied to Taurus. Golden yellow, on the other hand, is associated with Leo.

Tones, tints, and shades of yellow

Gold is associated with quality, illumination, wisdom, and wealth. It creates a feeling of prestige. Gold can also be tied to a quest for power. When combined with navy blue, it's very effective for marketing to men, and almost as effective for marketing to women.

Dull yellow is reminiscent of decay and sickness. It can also be associated with both caution (which is why it is used for many road signs indicating potential hazards) and jealousy.

Light yellow is tied to joy, intellect, and freshness. It is the color of sunshine and is popular as a unisex baby color.

orange

Orange is the color of warnings in the manmade world. In the natural world, orange is seen in the coats of many animals (since brown is a shade of orange) as well as in fall leaves. Orange is commonly seen in sunrises and sunsets, giving it a sense of warmth similar to yellow.

Orange, a secondary color created by mixing red and yellow, is associated with energy and positivity. Orange is a very stimulating color, and represents enthusiasm and success. It's ambitious but still fun, energetic, and flamboyant, and is associated with generosity and vibrancy. It also evokes an organic and expansive feeling.

Like yellow, orange can energize and stimulate the appetite. Orange roses are tied to enthusiasm and desire (combining traits of both red and yellow roses). In astrology, orange is associated with Sagittarius.

In branding, orange can give the impression that something is more affordable. It also appeals to a broad swathe of the population, making it a very popular color for branding for all sorts of products and companies.

Tones, tints, and shades of orange

Terra-cotta is associated with wholesomeness, earthiness, and warmth. It's stable and welcoming, while also being associated with autumn, harvest, and rural areas.

Dark orange can indicate distrust and deceit.

Red-orange takes on many of the characteristics of red, and is tied to sexual passion, desire, and pleasure. It's also linked to domination, aggression, and action.

Brown is technically a shade of orange, but is generally treated more like a neutral color rather than simply a shade. It's covered in more depth as its own color.

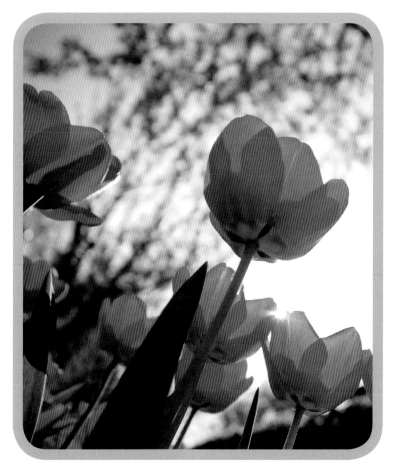

purple

Purple is fairly rare in nature, though it is seen in flowers, birds, and fish. It's also seen in the sky at twilight and at sunrise and sunset. Because of its association with twilight and the night sky, it's no wonder it's associated with the mysterious and the mystical.

Purple, a secondary color created when blue and red are combined, takes on some of the traits of both of those hues. It has long been associated with royalty due to the fact that Tyrian dye (which comes from a particular species of predatory sea snail) was very rare in ancient times and therefore reserved for the garments of royalty. It has strong ties with luxury, power, and ambition. Purple is also sometimes associated with the mystical and metaphysical realms.

Purple is psychologically associated with suppressing appetite (like blue). It's also said to be good for migraines, and can create a peaceful environment. In astrology, purple is associated with a number of signs: Gemini, Sagittarius, and Pisces, while violet (a lighter tint of purple) is associated with Virgo and Libra.

Tones, tints, and shades of purple

Light purple can be nostalgic and romantic. It has all the positive connotations of purple, though without the strong ties to the mysterious and metaphysical.

Dark purple is tied to sad feelings and gloom, as well as frustration. It is a very mysterious color, and can be tied to the occult.

Lavender, which gets its name from the lavender flower, is associated with enchantment, nostalgia, and delicacy, as well as feelings of sweetness. It is very popular in marketing products for women.

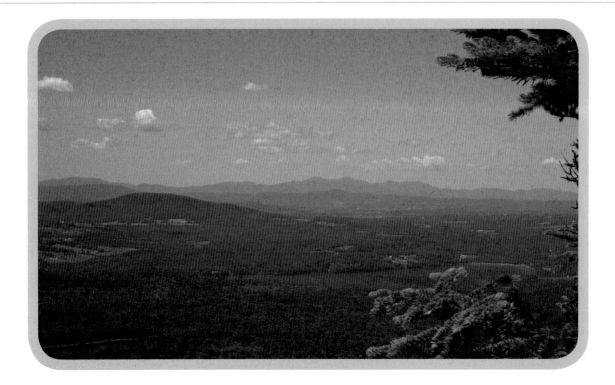

blue

Blue is the color of the sky, the color we associate with water, and a color seen often in nature. Blue is the most popular color in the world, according to a number of surveys. It's no wonder, considering its prevalence in our daily lives.

Blue, a primary color, is associated with loyalty, honesty, and strength. It's because of these traits that it is very popular in corporate branding. It reinforces a sense of trust, wisdom, and confidence. Blue is also a very masculine color.

Blue can also be depressing. It can slow the human metabolism, and have a calming effect on people. Blue can also suppress the appetite, which means it's generally a good idea to avoid it in branding for food companies.

Psychologically, blue is calming. It can lower blood pressure and decrease respiration in those observing it. Astrologically, blue is associated with Capricorn and dark blue with Aquarius.

Tones, tints, and shades of blue

Light blue is tied to peace and tranquility, along with health and healing. It's also cool, clean, quiet, and pure.

Navy is tied to dignity and strength. It evokes feelings of authority, trustworthiness, and tradition. It is conservative, quiet, confident, and serene. This is why it is a very popular branding color for traditional big businesses like insurance, transportation, and financial companies.

Teal blue is associated with richness and expense. It is also the color of emotional healing and protection. Teal blue and turquoise are popular branding options for both men and women.

Dark blue is linked to knowledge and integrity, as well as power. It's a very serious color. It holds many of the same meanings as navy blue, but is generally a bit lighter.

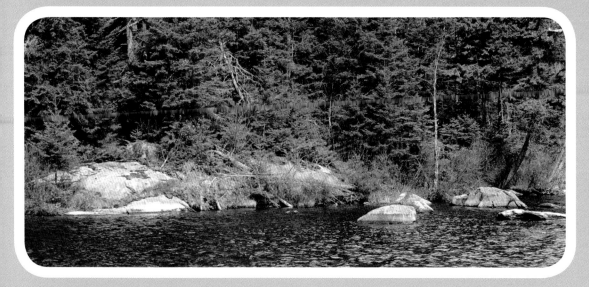

green

Obviously green is one of the most prevalent colors in nature. It's the color of leaves, of grass, and of many animals, particularly reptiles and amphibians, but also birds and insects. Green is a very popular color, particularly in home decorating. It's also very popular in product packaging and marketing, especially for environmentally friendly products (though it is also commonly used in what is called "green-washing," where a company simply wants to appear to be environmentally friendly when really they aren't officially certified in any way).

Green, a secondary color created when yellow and blue are combined in subtractive color systems, is generally the most intense cool hue. It takes on many of the traits of yellow and some of those of blue as well. It's strongly associated with nature and environmental causes. Green is also considered the most restful hue to the human eye, and can even improve vision according to some reports. Green is strongly associated with hope and growth, while darker shades of green are associated with money. This makes it popular as a branding color among financial companies.

Psychologically, green is soothing, and relaxing both physically and mentally. It can help with depression, nervousness, and anxiety. In astrology, bright green is associated with Cancer.

Tones, tints, and shades of green

Dark green is associated with greed and ambition, as well as jealousy. It's a very masculine color, and a good option when you don't want to use blue.

Emerald green is associated with immortality.

Yellow-green is tied to sickness, cowardice, and jealousy, as well as discord. It is the least effective color when it comes to marketing to consumers.

Aqua is linked to emotional healing and protection.

Olive green is traditionally associated with peace. It's a common color used in military uniforms around the world as well, and is linked to adventure.

Lime is refreshing, revitalizing, and lively.

Light green is tied to inexperience. Calling a person "green" generally means they're new to a task or endeavor.

black

Black is one of the most popular car colors in the world. It's associated with nighttime and darkness, and is frequently seen elsewhere in nature. It's often strongly associated with a lot of negatives in the natural world.

Black is created in the absence of light. In additive color systems, this means that no light is emitted. In subtractive color systems, it means that all light is absorbed rather than reflected by a surface.

Black has long been associated with negativity, "bad guys," evil, darkness, and death in western cultures. It can also be seen as rebellious (think of black motorcycle jackets or the black clothes "goth" teenagers wear).

Black can be a very heavy color in large doses, though it can be very stimulating and enhance surrounding colors when used in limited quantities. Black is used extensively in the design world.

Psychologically, black is associated with self-confidence, strength, and power.

Off-black has most of the same connotations as black, but is less harsh and easier to deal with in large quantities. It can be created from any other color, and can also take on some of the meanings of the color it is created from, though it is more easily influenced by surrounding colors.

white

White is the most popular color for cars. It's seen in the natural world in things like snow, light, flowers, and some animals. It's associated with winter, obviously, and therefore with cold. White is seen frequently in our daily lives and tends to recede into the background, not really catching our attention.

White is created via the combination of all of the visible wavelengths of light. In additive color systems, this results from combining red, green, and blue. In subtractive color systems, it means that the full spectrum of light is reflected by a surface rather than absorbed.

White is generally associated with purity and "good guys" in western cultures. It's seen as the color of peace and serenity. It's also traditionally associated with weddings and brides, as well as with angels. White is also associated with sterility, and is therefore linked to hospitals and medical professions (reinforced by white hospital lab coats). White is often associated with peace (and similarly with surrender or truce), particularly the symbol of the white dove.

White roses are associated with reverence and humility. In astrology, white is associated with Aries and Pisces.

Off-white (or ivory) is less harsh than pure white. When using an off-white color in a design, it's important to match it to other hues in the design. Off-white can be warm or cool, depending on the color added to white to create it.

gray

Gray is created by desaturating any hue. In subtractive color systems, it can be created by combining white and black pigments, or by combining primary colors (though this often results in a muddy, brownish gray hue).

Gray is often seen as being dull, lifeless, and sad. It's considered boring by some, as well as plain. But gray can also be elegant and sophisticated, depending on how it's used and the other colors surrounding it. Gray is mature and stable, as well as conservative and modest.

It's a very dignified color, regardless of the colors surrounding it. It can be very grounding in a design.

brown

Brown, which is actually a shade of orange rather than a pure hue, is conventional and orderly. It's often associated with nature and the earth. Brown can also be seen as stable and practical, which is why it is sometimes used in corporate branding despite the fact that it's not a particularly eye-catching hue. It's also considered a very wholesome hue, and can be associated with family life. Because it is a shade of orange, it's generally thought of as a very warm color.

Astrologically, brown is associated with Capricorn and reddish-brown is associated with Scorpio.

beige

Beige, a tone of orange rather than a pure hue, is often seen as dependable and conservative, though it can also be flexible. It offers some of the warmth of brown, while also the crispness of white. Ivory is a much lighter tint of beige, closer to white, though warmer.

color in different cultures

Most of the color associations described on the previous pages are based on western cultures, but there are differing color meanings throughout the world. Sometimes these differences are subtle, while other times a color can mean the exact opposite from one culture to another.

Some differences are based on geographic area, while others on religion or ethnicity. Many meanings are entrenched in myth and history, and can have very deep roots among a group of people. For this reason, it's vital that you understand how your target visitor views a particular hue.

red

In many cultures, red is a very positive color. In China, for example, it's a symbol of good luck and celebration. In India it's associated with purity, and in the Cherokee culture, it's associated with success and triumph.

Conversely, in other cultures red is not so positive. In Hebrew culture it's associated with sacrifice and sin, while in Celtic culture it's associated with death and the afterlife, and in South Africa it's the color of mourning (most likely due to it being the color of blood).

Other meanings are more neutral. Australian Aboriginals associated red with the earth and land, while politically it has often been associated with Communism. Red is a very commonly used color in the national flags of many countries around the world, though the symbolism for each is, of course, different.

In feng shui, red is associated with Yang and fire. It's said to be a symbol for good luck and money, as well as vitality, respect, and recognition. In Buddhism, red prayer flags are associated with the element of fire, while in the Buddhist flag it represents the blessings of practice: wisdom, fortune, achievement, dignity, and virtue.

Red is a particularly lucky color in Chinese culture.

yellow

Yellow has a wide variety of meanings in different cultures. In the Apache nation, yellow is associated with the east and the rising sun, while in the Cherokee nation it's thought to mean trouble and hardship.

In Egypt yellow is the color of mourning, yet in eastern cultures it has a more positive connotation. In Japan it symbolizes courage (in contrast to the western association with cowardice), while in China it's associated with nourishment and royalty, and yet it is also the color most closely tied to Buddhism and the letting go of worldly goods. In India yellow is the color of merchants.

In feng shui, yellow is associated with Yang and the earth. It is an auspicious color, tied to the sun and warmth, as well as motion. In Buddhism, yellow in prayer flags represents the element of earth, and in the Buddhist flag it represents The Middle Path of avoiding extremes, as well as emptiness.

Yellow is associated with merchants in India, and is a generally auspicious color.

Buddhist monks in Thailand wear orange robes.

Purple is found on the roof of part of the Grand Palace in Bangkok, Thailand.

orange

Buddhist monks traditionally wear orange robes and the color is strongly associated with Buddhism in general. In Ireland, orange is associated with the Protestant religion.

In feng shui, orange is associated with Yang and the earth, as is yellow. It is thought to strengthen conversation, purpose, and organization. In the Buddhist flag, orange represents wisdom and the Buddha's teachings.

purple

In Thailand, purple is associated with mourning and widows. This isn't a huge deviation from its association with the metaphysical and mysterious in western cultures. In other eastern cultures, purple is tied to wealth, also related to the western association with royalty and luxury.

In feng shui, purple is Yin. It symbolizes spiritual awareness (again, similar to western meanings) and healing.

blue

In the Cherokee culture, blue is associated with the north, and it symbolizes defeat and trouble. By contrast, in China blue is tied to the idea of immortality, and in Iran it is the color of heaven and spirituality, as well as the color of mourning. In many eastern cultures, blue is associated with wealth and self-awareness.

In feng shui, blue is Yin, and represents water. It is calming, healing, and relaxing, and is associated with love, trust, and peace, as well as exploration and adventure. In Buddhism, blue prayer flags represent space, and in the Buddhist flag it represents loving kindness, peace, and universal compassion.

green

Green is representative of the country of Ireland, and particularly with Catholicism there. In Islam it is a symbol of perfect faith. Green is associated with life in Japan (similar to its association with birth in western cultures). In China it's tied to exorcism, while in many eastern cultures it is associated with family, health, prosperity, peace, and eternity.

In feng shui, green is Yin and represents the element of wood. It is the energy of growth, nurturing and balancing, healing and health. It is also said to be very calming. In Buddhism, green prayer flags represent the element of water.

Green is an incredibly important color in Ireland, and is even used for the country's post boxes.

white

In China, white is associated with death, as it is in the Hindu religion. This isn't too far removed from the western association with heaven. In many parts of Asia, it is also closely tied to children and to peace. Hindus associate white with intelligence and peace. It has the same ties to peace in many Native American tribes, too.

In Eastern Europe, white is associated with trust, as well as with truce.

In feng shui, white is considered one of the supreme colors, and belongs to the element of metal. It brings the energy of new possibilities and innocence. In Buddhism, white prayer flags are associated with the element of air, and in the Buddhist flag it represents the purity of Dharma, leading to liberation outside of space and time.

The Taj Mahal is built from white stone, with the main domed part of the building complex serving as a mausoleum, which ties in closely to the association of white with death in many eastern cultures.

Black is associated with celebrations in China, as shown in its use in Chinese dragons.

black

In some Native American cultures, black is associated with self-cultivation and balance, as well as with death, which it's also linked to in Japan.

By contrast, in China it's associated with celebration. In other parts of Asia, black is linked to intelligence and self-cultivation, as well as evil and penance.

In feng shui, black is Yin, and associated with the element of water and the north. It is the energy of stability and of grounding.

The key thing to remember is that colors mean different things around the world. If you're working on a project where the target market is a different culture to your own, take the time to study what different colors are likely to mean to those visitors. Take time to study their culture, as well as the time to research other designs that target a similar demographic.

4

COLOR RELATIONSHIPS

How colors relate to one another within a palette or scheme is the most important, and often the hardest to grasp, area of color theory. Without a thorough understanding, it's impossible to make informed color choices for your designs.

how colors interrelate

There are two basic categories of color relationships and color schemes, outside of monochromatic color schemes: analogous and complementary. Within complementary, there are numerous sub-classifications as well.

Understanding these relationships, and the way colors interact with each other in these patterns, is vital to moving forward and creating your own color palettes, regardless of whether you stick to the traditional schemes or not. The way colors interact with one another is strongly influenced by their relationships on the color wheel, and without a basic understanding of those relationships, creating effective palettes is more difficult.

monochromatic colors

A monochromatic color scheme is made up of hues with approximately the same wavelength. This can include tones, tints, and shades of the same color. When you bring in more than a single color, though (such as combining orange with yellow-orange), you're creating an analogous color scheme, rather than a monochromatic one.

Monochromatic color schemes reinforce the meanings of whatever color is being used. In some cases, you may find a color scheme that is primarily monochromatic, but also includes white, black, or gray. While these are not technically monochromatic, they often are treated as such and share many of the same characteristics.

This monochromatic wireframe is a great example of how using different shades, tints, and tones can make a site with a limited color palette interesting and eye-catching.

This wireframe with an analogous color scheme shows how the use of different tones, tints, and shades of three side-by-side colors (in this case green, blue-green, and yellow-green) make for a very interesting color scheme.

analogous colors

Analogous color schemes are made up of colors next to each other on the color wheel. For example, blue, blue-green, and green would be an analogous color scheme. Analogous color schemes share many of the same attributes as monochromatic color schemes, but with added depth that a single hue can't provide.

Analogous color schemes are commonly seen in nature, and, therefore, are very pleasing to the eye.

Split analogous colors

Split analogous color schemes are created by using a main color, plus colors that are one space away on the color wheel to either side. For example, a split analogous color scheme might include red, orange, and purple. This adds even more visual interest to the color scheme than a plain analogous color scheme.

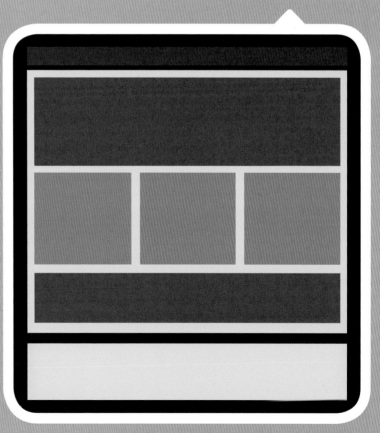

complementary colors

The traditional complementary color scheme consists of colors on opposite sides of the color wheel. Red and green, blue and orange, and purple and yellow are all examples of complementary color schemes.

The issue with complementary color schemes in design is that when pure hues are used they can be too vibrant and create a very jarring effect. This is particularly the case when they are used in large quantities or immediately adjacent to one another. To solve this, they should be used in varying degrees of purity, or in small doses with other, neutral colors.

In addition to the standard complementary color schemes, there are a number of variations.

A complementary color scheme creates a lot of movement and visual interest that's perfect for a design that's fun and demands attention.

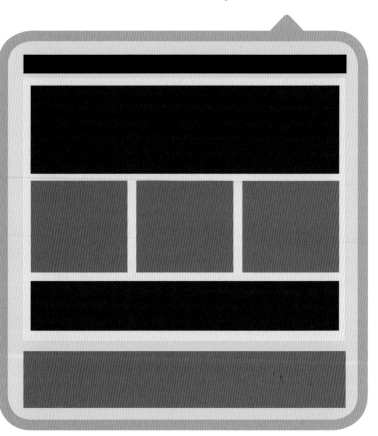

Split-complementary colors

Split-complementary color schemes are created when a main color and the colors on either side of its complementary color are combined in a palette. For example, you might combine blue-green with orange and red (the colors to either side of its complement, which is red-orange).

Split-complementary color schemes are much easier on the eye than traditional complementary schemes, especially when the hues are used at full saturation. They also create a much more diverse visual appearance than standard complementary color schemes.

A split-complementary scheme takes away some of the stark contrast that exists in straight complementary schemes, while adding even more visual interest and excitement.

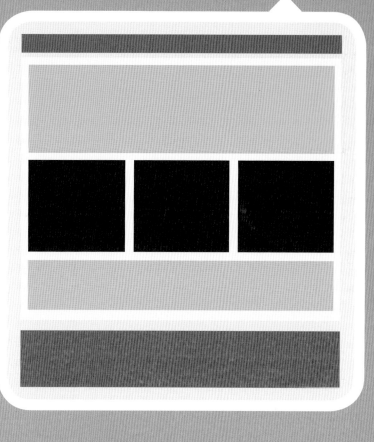

Triadic colors

A triadic color scheme is created with three colors that are equidistant from one another on the color wheel. Primary colors (red, blue, and yellow) create a triadic color scheme, as do the main secondary colors (green, purple, and orange). Tertiary colors combine to create two additional triadic color schemes (yellow-green, red-orange, and blue-purple create one, while blue-green, orange-yellow, and red-purple create the other).

A triadic color scheme is even more diverse than split-complementary color schemes.

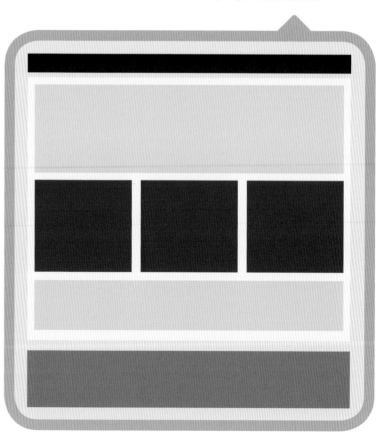

A triadic color scheme using secondary colors is very appealing, especially when a variety of tones, tints, and shades are used.

Double-complementary colors

A double-complementary color scheme is made up of a pair of complementary color pairs that are one space apart on the color wheel. For example, blue, purple, yellow, and orange create a double-complementary color scheme.

Double-complementary color schemes present many of the same potential issues as a standard complementary color scheme. But because there are two additional colors involved, they also offer more possibilities.

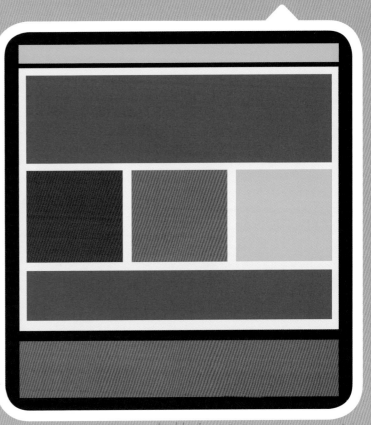

Square colors

A square color scheme is created by four colors that are equidistant around the color wheel (every third color, with two colors between each hue). For example, purple, blue-green, yellow, and red-orange would create a square color scheme.

Again, this is made up of two sets of complementary colors, and presents the same challenges and opportunities as a double-complementary scheme. It's important to consider how you combine these colors, and to consider using tints, tones, and shades to make the overall color scheme more pleasing to the eye.

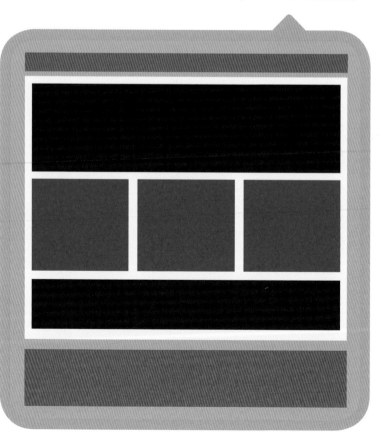

There are a ton of options for using a square color scheme, as evidenced in this wireframe.

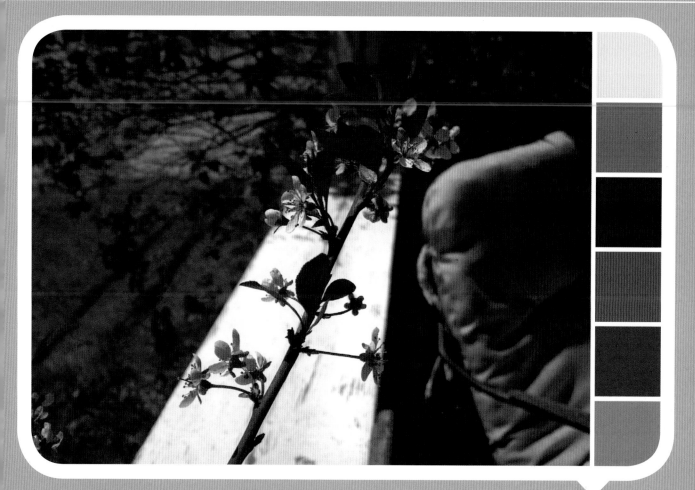

color schemes vs. color palettes

We've now covered the basics of how traditional color schemes work. And while traditional color schemes are a great starting point, you can create beautiful palettes while breaking all of the rules. Look at any number of designs and you'll be hard-pressed to define a traditional color scheme. You may even think that the design has disregarded color theory altogether.

But that's generally not the case. Colors that do not have any traditional relationship with one another can still be combined to create a beautiful palette. There are a variety of ways to create these kinds of color palettes, including pulling colors from existing designs, photographs, or objects, or creating something entirely from scratch. With the basic understanding you've just gained, you can attack the process of creating color palettes in a deliberate and methodical manner, rather than just randomly choosing colors and hoping for the best.

This image shows an example of a color palette taken from a photograph that doesn't follow any particular traditional color scheme.

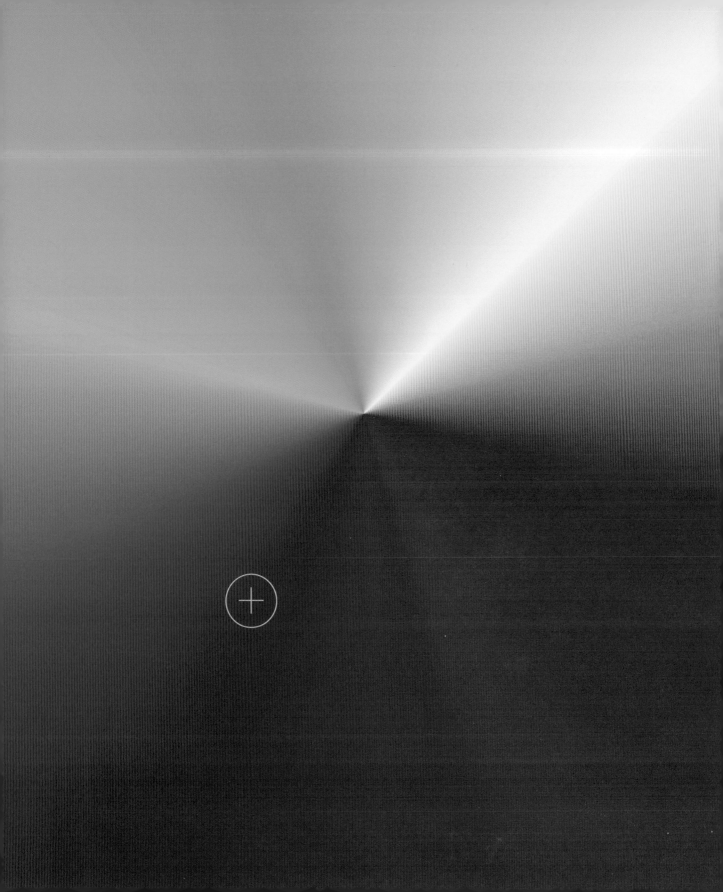

5

FINDING A
COLOR PALETTE

Your wesite's color palette can have a greater impact on how your site is perceived than practically any other single design element. That's why it's essential that you have the tools necessary to create a thoughtful palette.

creating unique color palettes

When embarking on a new website design project, you may be asking yourself where, exactly, you should start: do you start with the basic design wireframes or mockups, or do you start with the color palette? It is a valid question, but to an extent it's like asking which came first, the chicken or the egg?

The truth of it is that it doesn't really matter which one you start with. In all likelihood, you may be starting with some idea of what your color palette should be anyway. You may have corporate branding that you need to consider (or even that dictates exactly what colors need to be included), or you may just have an idea of what colors you want to use on the site.

In either case, it's unlikely you are starting entirely from scratch. There is almost always a set of guidelines, or some spark of inspiration, that you can base your color palette on, even if it's only a feeling you want to create.

That being said, you should remain flexible in your color palette until your basic layout is at least somewhat finalized. Once that is done, then you can settle on what colors you want to use in the final design. Even then, be willing to make changes if it just isn't working once your design is "finished."

This is partly because the layout will determine, to an extent, how many colors you need to have in your palette. This number generally falls somewhere between three and six, though some sites may use more (it's rare for a design to use less than three, unless you are designing an entirely black-and-white site, but even then there are often shades of gray included as well). It also determines how many base colors, main colors, and accent colors you might need.

As for finding your exact color palette, there are a number of sources you can turn to: other website designs, other marketing materials (from the company you are designing the site for or another company or organization entirely), photographs, everyday objects, or just your imagination.

But regardless of the source, there are certain things that every color palette is going to have in common.

anatomy of a color palette

There are three basic parts to most color palettes: the base colors, the main colors, and the accent colors. These each play a different role in your designs. They're also used in different proportions, and therefore take on different importance within the design itself.

Base colors

A base color will often make up the bulk of your design, and yet its importance is often overlooked. Think of your base color as the backdrop for your entire design. It serves as the canvas upon which the rest of your design will sit, and can make or break it. An effective base color, one that contributes to the end result you are trying to achieve, can be a much more powerful part of your design than you might expect. In many cases, but not all, your base color will be a neutral or close-to-neutral tone.

Your base color can have a huge impact on the feel of your site. Let's say your base color is white (#FFFFFF, to use its hexidecimal code, the numbering system used to define web colors). Changing that to black (#000000) would instantly alter the overall feel of the entire design. Changing it to a subtle tone would affect the feel of the site in a different way. For example, look at the two color palettes on the right. The blue hues are the same in each, but the gray in one is light and the gray in the other is dark. It changes the entire psychological tone of the color palette. The light gray gives the palette an airy quality, while the dark gray gives the other palette a more moody feeling.

Your base colors, because they generally just sit in the background, are often not thought through in the same way that other colors in a palette are. A lot of designers just go with black, white, or some in-between shade of gray. But subtle changes to the base colors on your site can have a big impact on the other colors in the design.

Base colors are most commonly found in a site's background, and often in the typography. They tend to be somewhat "invisible," particularly in the case of light neutrals. Your average site visitor will not consciously see these colors, and yet that does not diminish the overall impact they have. In fact, they can enhance the impact, as it is completely subconscious on the part of the website visitor.

Here are just a few base colors you might find out in the wild.

The addition of light base colors makes this palette look significantly brighter and lighter.

The addition of dark base colors, however, makes this palette more moody and bold.

Main colors

Main colors are the principal colors used in a design. They are the colors that stand out most, and are often the first to be noticed. They have the greatest impact on the site's overall feeling.

Main colors are sometimes found in the background of different site elements (like a header or footer), as well as in the site's typography and graphic elements.

Because your main colors are the most influential on your site, it is vital that you take into account their meaning and the feelings they evoke. While they can be greatly influenced by your base and accent colors, in practice they tend to have more influence on those colors than the other way around.

Accent colors

Accent colors are often used in very limited quantities on a site, but can have a big impact on the feel of the main and base colors.

For example, you might have a site with gray base colors and orange as the main color; using red (an analogous color) as an accent color will have a much different impact than using turquoise (a complementary color).

Accent colors are sometimes found in the typography of a site (for things like headings, links, or captions), as well as in graphic elements (like borders or icons).

Your accent color can do a lot to enhance the feelings the main colors of your site evoke. For instance, if you have a site where the main color is red and the base color is black, using light pink as an accent color will work to soften the overall effect and make it more feminine. On the other hand, if you use a bright orange as an accent color, it's going to give the site an edgier, more dangerous feeling.

In other words, your accent colors can reinforce and influence the meanings of your main colors when used properly. Look at where the meanings overlap for clues as to what effect combining two colors will have.

Some examples of colors that might be used as main colors on a website. While there tend to be informal "rules" for what makes a good base or accent color, main colors can really be any hue.

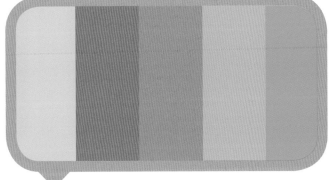

Some examples of colors that might be used as accent colors on a website.

Examples of base, main, and accent colors in practice

While it is all well and good to discuss the different elements of a color palette in theory, seeing how colors interact with one another in a more concrete way is invaluable in learning how to properly combine them.

The differences in using dark versus light base colors, and bright versus muted main and accent colors cannot be given too little importance. Even by using shades, tints, or tones from the same pure hue, you can achieve dramatically different results. These are best demonstrated by studying the palettes included here.

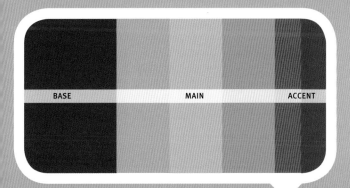

A dark base color creates a very dynamic color palette. Consider what this palette would look like if the central main color was the base color instead.

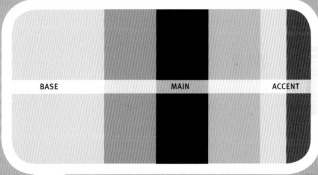

This mostly monochromatic color palette combines a light base color with two shades of pink and black as main colors. Using a neutral cream as an accent color is less expected, unlike the bright rose that's also included.

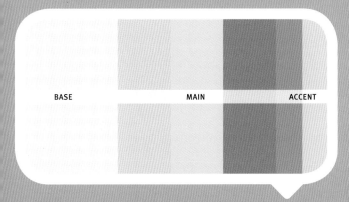

This palette uses a modified split-complementary scheme, with different blue hues combined with a golden yellow hue. The gray base and main colors give it a more subdued overall mood.

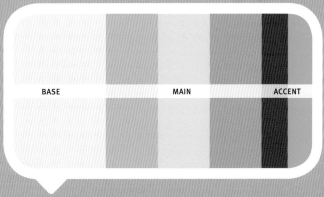

This is a much more playful palette, with a cream base color that makes the entire palette warmer. The light main colors combined with the dark accent colors add plenty of visual interest.

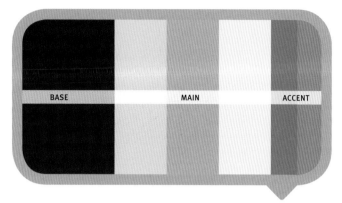

A dark base color gives a lot more mood to an otherwise light and playful palette.

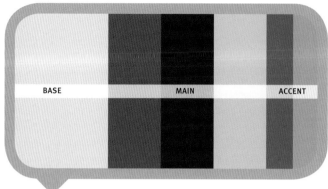

This palette is based on a traditional complementary color scheme, mainly with pink (a tint of red) and green hues. The light neutral base and dark neutral main hues give it a very subdued feeling.

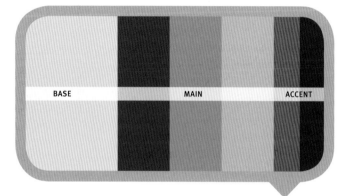

While base colors are often neutrals, they don't have to be. In this scheme, yellow acts as the base, while blue and purple hues make up the main colors, and red-orange and dark gray are used as accents.

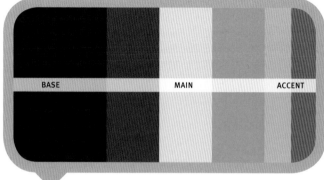

Dark base and main hue add moodiness to an otherwise soft palette made up of primarily pastels and pastel tones.

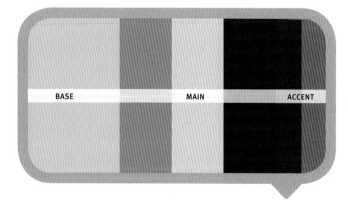

Here is another example of a palette that does not use a plain neutral for the base color. Instead, it uses a light, muted chartreuse as the base, with shades, tints, and tones of red for the main and accent colors (based on a traditional complementary color scheme).

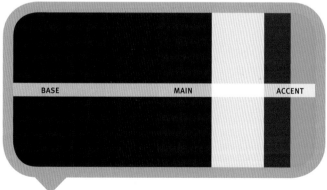

This palette uses a dark gray base, with dark and light main colors, and bright accent colors. Consider how different the palette would look if you switched the light main color with the dark base color.

color palette sources

In a perfect world, a designer would embark on a new website project with a clear idea of what colors should be used. Either this would come from the client and their established brand, or simply the designer's imagination. Unfortunately, that is not always the case. Even if a client has set colors that need to be used, there are often gaps in their established brand colors that you may have to fill in.

The good news is that there are a ton of places from which to get color palette inspiration. One way is to look at existing websites and adapt their colors. This can work with sites in the same industry or sites on entirely different topics. It is generally not a good idea to use a color palette in exactly the same way as some competing website, obviously.

Another way to develop your own color palettes is to look at non-design sources (including art and photography) to find a starting point. The great thing about photos in particular is that they can have virtually any subject. You don't need to be in front of whatever it is that is inspiring you; you only need a photograph. That means you can pull inspiration from a sunset in Tahiti, a coral reef in the Caribbean, the various shades of the landscape in the Blue Ridge Mountains, open air markets in Asia or Africa, or virtually anything else you can think of. It opens up a world of inspiration that is not necessarily available to you in any other way in your daily life.

Pulling a color palette from a photograph

More good news is that the techniques used to pull a color palette from a photograph are the same as those used to pull colors from any other object. What you learn here can be applied to creating color palettes from just about anything.

The first thing you need to do is find a photo you want to use. There are a couple ways to do this. You can think about the mood you want to convey with your design and look for a photo with a similar mood to start with. A great way to do this is to go to your favorite stock photo or photo-sharing site and type in a keyword or two that describes the mood. In most cases, you will get lots of results.

Once you have decided on the photo you want to use for your color palette, take a minute or two to study the colors in the photo and how they interact with one another. Do any colors really jump out at you? Those colors might make good accent colors. What about the overall color of the photo? Is it mostly green, blue, brown, etc.? Look at adapting that into a base color (by either lightening or darkening it so that it's closer to neutral). Your main color can be some other hue from the image that complements both your accent and base colors. Remember, too, that you can add colors not present in the original image, or change the saturation, lightness, or other properties of the hues found in it. The photo should be a jumping-off point, not the be-all and end-all of your palette creation. Creating a palette based on a photo involves a lot of trial and error. Don't be afraid to experiment, and don't shy away from changing and adapting the original colors. After all, the point is to be inspired, not restricted.

On the following pages are some examples of palettes pulled from photos. Each of these very basic palettes was initially created in just minutes in a photo-editing program (though the overall process is much longer, when you include the time selecting the image to fit the tone of your site and tweaking the final color palette to fit your design).

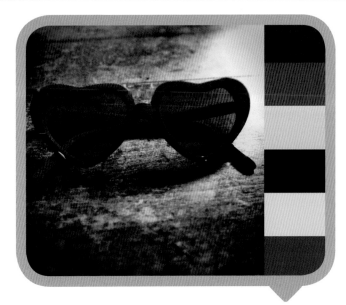

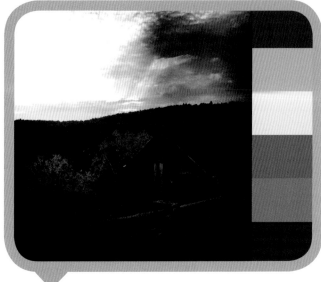

This photo has a lot of very saturated primary colors, along with some great neutrals. The bright colors would work equally well as main or accent colors, while the dark and light neutrals would make excellent base colors.

This image has a fairly straightforward split-complementary color scheme of green and purple. The touch of soft pink and dark gray add more depth and possibility to the palette options.

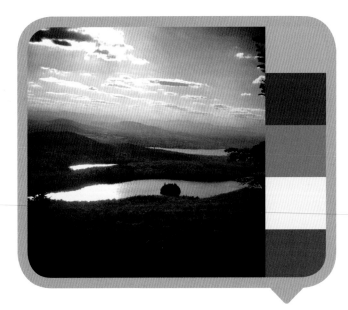

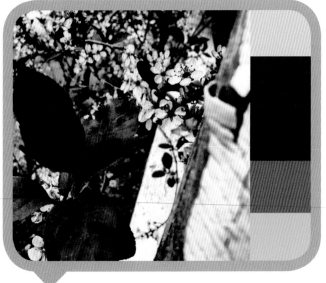

Blue and green are generally considered analogous colors (even though blue-green technically falls between them on the color wheel). This scheme combines various tones, tints, and shades of blue with green and ivory to round out the palette.

Combining red-purple and pink (a tint of red) with bright lime green is a great example of a palette based on a traditional complementary scheme.

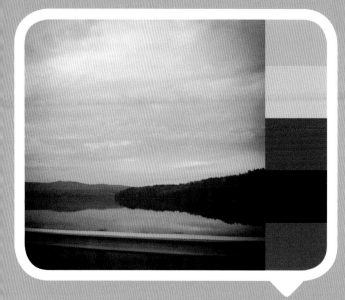

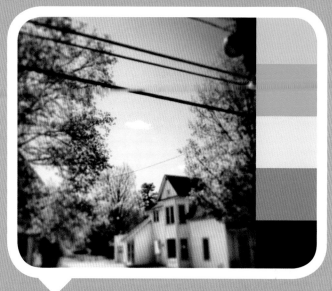

Sepia photos can be a great basis for very muted color palettes, too. This palette is built almost entirely of neutrals and near-neutral tones, and is quite dramatic.

Nature can be a great source of very bright color palettes. The bright greens and blues evoke the springtime scene they originate from. The dark neutral gives it more edge, while a light neutral (which could also be pulled from the photo) would give it a brighter feel.

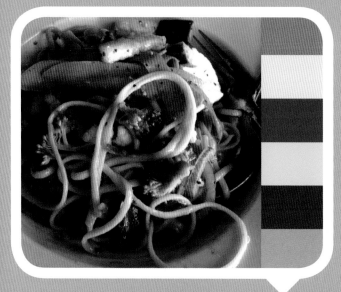

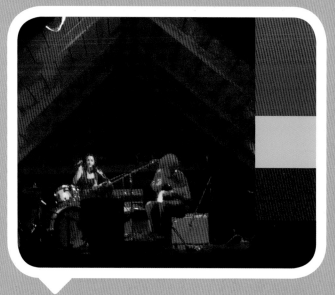

Food can be a great source of color palette inspiration. Carrots, broccoli, and red onions are the perfect source for a bright, yet still natural, color palette.

This photo has so much going on chromatically that it is almost impossible not to want to use it as the basis of a color palette. The bright lights on the stage create vibrant, saturated hues, while the shadows create some wonderful dark neutrals.

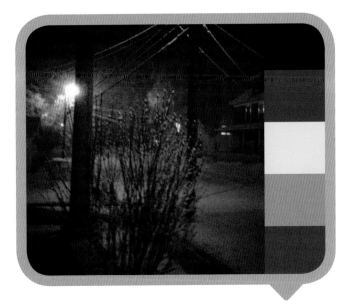

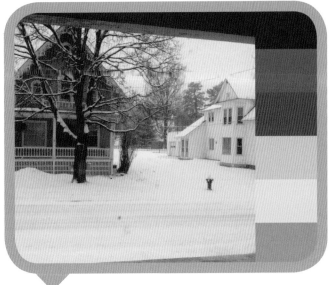

A dark winter night seems almost monochrome at first glance, but a closer look reveals some patches of vibrant color as well as plenty of moody neutrals to use.

A daytime winter scene is also ripe with color, including pinks, reds, and browns, as well as a surprising number of tints and tones within the snow.

Adapting existing color palettes

There is nothing wrong with using the color palettes of existing sites or designs as the basis for your own color palette creations. The key is to adapt that color palette to work for your own design.

You could take a main color and use it as your base, or use an accent color as your main color (or vice versa). And you could add or subtract colors from an existing color palette.

What's important here is not to just pull any old color palette you like. Make sure that the color palette you choose to adapt makes sense in the context of your site. In other words, don't expect to take a color palette from a corporate law firm's website and expect it to work equally well on a children's toy e-commerce site. It might work, but the chances are not good.

fitting color to a site's purpose

The most important part of creating any color palette is to make sure that the palette matches the tone and purpose of your site. One of the worst things you can do in your designs is use an inappropriate color palette. It can throw off the entire design.

For example, using a palette of pale lilac and sage green is probably not going to work for a site targeting 30-something men. On the other hand, it would work great for a site selling baby or children's items. For the men's site, you might want to try something more masculine, like navy blue and red.

Examples of purpose-driven color palettes

Tailoring your color palette to your site's purpose is vital. While there are tons of different industries and types of sites out there, what follows is a sampling of how you might cater to the most commonly found website types.

Environmental and eco-friendly sites

If you are creating a site for an environmentally conscious or focused organization, you are probably already thinking of how you will incorporate green into the color palette. After all, it's not called the "green" movement for nothing.

However, brown is another very popular color in this industry, because of its association with the earth and with nature. It is often used in conjunction with green.

If you want something a bit less expected for your eco-friendly website, consider using variations of blue. Mimic the shades, tones, and tints found in nature for the best results with this unconventional choice.

This drab green monochromatic color scheme would be right at home on an environmental blog or similar website.

An analogous color palette made up of blues and greens is another great option for an environmentally friendly website, and would mix well with a base of white or black (or a shade of gray).

Websites aimed at babies and children

Designing sites for children really requires you to appeal to parents in most cases, instead of (or in addition to) the children themselves. But at the same time, even if your goal is to attract the parents, you will want to have a very child-focused color scheme.

Of course, these kinds of color schemes are going to vary based on the age and sex of the child audience. A typical place to start is with traditional baby colors: pink for girls and blue for boys. More unisex options include yellow, green, and purple, particularly in pastel tints.

As a general rule, the colors should become more saturated as the target market ages. Older children generally enjoy brighter colors, and especially the traditional subtractive primary colors of red, blue, and yellow.

By the time children reach adolescence, they are more likely to want a more sophisticated color palette. Bright colors still appeal, though you may want to use them in a bolder, more forward way, particularly when combining them with neutrals.

This color palette, reminiscent of fruit sherbet, would be excellent for a website aimed at babies or young girls.

This brighter palette would be excellent for a site aimed at slightly older children, and would work well for boys and girls alike.

Websites aimed at women

Fifty years ago, marketing aimed at women tended to gravitate toward pink. In fact, pink was used almost exclusively by many female-focused industries. If you wanted to appeal to the fairer sex, you stuck to pink. If you wanted to take a risk, you might have tried some other pastel, like lavender.

Even now, a lot of products aimed at women incorporate pink in their marketing materials and product packaging in one way or another. Other popular colors for appealing to women include purple, lavender, turquoise, green, and even blue (which is popular for men as well).

This monochromatic color palette works great with lighter shades of gray added into the mix for more visual interest. It is feminine, while not being "girly." Instead, it gives a more sophisticated impression.

This color palette is decidedly more "girly" than the one above, though mixing in the turquoise blue gives it more visual interest than a monochromatic scheme.

Websites aimed at men

If you want to market to men, on the other hand, you can pretty much rule-out using the color pink. Purple is another very unpopular color for men, and should be used sparingly, if at all.

Blue, of course, is the most traditional color for marketing to men, but any strong, masculine color can be used to good effect. These include green, brown, red, orange, and similar hues.

Red and blue are both very traditional masculine colors, though a turquoise blue is a little less expected than a shade like navy blue.

Blue and brown are among the most masculine colors you could opt for in a palette, particularly in a more muted variety like these.

Corporate websites

Corporate sites are all about building trust and brand loyalty. Larger companies often have shareholders and boards of directors they need to be accountable to, in addition to their customer base.

Traditionally, corporate sites have stuck to very conservative color palettes. Jewel tones are popular, including navy blue, hunter green, and maroon or burgundy. Purple is sometimes found, though it should be used more for companies that primarily target women, due to its unpopularity among men.

Corporate sites in traditional industries are generally going to avoid things like neon color palettes or palettes with pure or near-pure complementary color palettes. Granted, there are some industries in which you might find either of those palettes on a corporate site, but as a general rule, they are rare.

Just because it is a corporate site does not mean you have to stick to staid, boring colors. The bright peachy orange in this palette adds a lot of visual interest, while the muted purple adds to it even more. The other neutral hues keep it respectable and trustworthy.

Green and blue are both very traditional corporate colors (blue because it evokes loyalty and trust, while green evokes trust and finance). Brown is also a very trustworthy color, and makes a great neutral addition to this color palette.

E-commerce sites

E-commerce sites have a very specific purpose: to sell a product. This sets them apart from other sites, which may have more informational purposes. It also means that color has a direct impact on a company's bottom line.

The good news is that there have been a number of studies that have looked at the impact of color on purchasing patterns among online shoppers. For example, according to anecdotal evidence collected by Hubspot, call to action buttons—prompts for a user to click on—that use a contrasting color have a significantly higher click-through rate than buttons that match the overall color palette of the site.

As for the best colors to use in an e-commerce site design, think about your target market. Also consider that you need to build trust and create a sense of reliability and professionalism. Potential customers are not going to make a purchase from you if they don't feel like your site is trustworthy.

Evoking a specific feeling is vital to a successful e-commerce site, and this particular palette evokes nostalgia. The dark blue and brown imply trustworthiness, while the dark salmon color works well as an accent.

Neutral colors work great for e-commerce sites, too, as they allow the content to really shine through. The blue in this palette, while fairly muted, stands out against the other neutral hues and makes a good accent color.

Travel sites

Because of the myriad types of travel sites out there on the web, there are no hard and fast rules for what colors should be used in these kinds of designs. One thing to keep in mind, though, is that travel, particularly when referring to vacation travel, is generally a happy, upbeat occasion. Because of this, you will want to keep your color scheme upbeat and fun. Turn to bright and warm colors.

Alternatively, if your design is for a specific destination, you will want to use colors that evoke the feel of that destination. For example, if you are creating a site for a Caribbean destination, you might want to combine turquoise with orange, lime green, or fuchsia. A resort in the redwood areas of Northern California, on the other hand, might stick with a color scheme of greens and browns to evoke the area's natural beauty.

One trend you might notice among airlines, though, is that they tend to stick to traditional, conservative color palettes common on corporate websites. Considering the security concerns and economic turmoil faced by the airline industry

for the last decade or longer, sticking to colors that imply trustworthiness and reliability makes a lot of sense. These kinds of colors also reinforce the idea of safety in the mind of the airline's passengers, which is invaluable considering how many people have anxiety about flying.

This kind of color scheme is great for a mountain resort area, as it evokes the colors of the natural landscape.

A palette for a tropical destination doesn't have to be overly bright and flashy. This palette evokes the beach quite well, without requiring bright, traditionally tropical colors.

Entertainment sites

Sites in the entertainment industries, including movies, music, and television, tend to favor darker color palettes. In part, this helps keep the focus on the site's content, rather than the site's design. A dark background also crudely mimics a dark theater or auditorium.

A lot of the content on these types of sites have their own distinct color palettes (particularly film sites), so the site itself should remain at least somewhat neutral, so as not to compete. To that end, shades and tones are generally going to be favored for your base and main colors, while accents might incorporate more saturated hues.

Dark colors, like in this palette, are perfect for entertainment industry sites. The bright green and brown work as accent colors, while the rest of the colors are great as main or base colors. They'd work together to really make the content of the site stand out.

This palette combines more neutrals, including browns and grays, as well as muted blues that really pop against the other hues.

Technology sites

Tech sites can be split into two different sub-categories: technology companies and technology news sites. There are major differences in the use of color among both.

Among technology news sites, they commonly start with a white or light neutral base color. They set themselves apart with the use of bright main and accent colors, with bright colors dominating in this industry. Masculine colors in particular, like blue, red, and green, are commonly seen on tech news sites.

Among tech companies, there's much more variation in color usage, largely dependent on the sub-category in which the technology falls, as well as the target user. Because technology has become such an integral part of our daily lives, there's a huge variety in who these websites are targeting.

For example, an app aimed at women's health is going to use a completely different color palette from a technology company that creates security or defense products. The first might use shades and tints of pink and purple as its main colors, while the latter might use navy blue or red as the central colors in its palette.

Bright colors like these are commonly found in the tech industry, particularly among software and app companies. There are a lot of design possibilities with a palette like this.

Bold complementary colors like these are also popular in the tech industry, for a variety of different kinds of sites.

Nonprofit sites

Nonprofit websites cover a lot of potential industries, charitable organizations, and target markets. But one thing they virtually all have in common is the need to portray reliability, trust, and responsibility.

There are two main purposes to virtually any nonprofit site: to educate the public and to solicit donations or contributions. And both of those purposes require the site to be trustworthy in the eyes of the visitor.

To that end, using traditional, somewhat conservative colors is a good idea. Tailor them to the purpose of the nonprofit (such as shades of green for an environmental charity) for the best result, but stick with colors that are more likely to appeal to the widest range of site visitors and avoid anything too unconventional.

This color palette would work for a variety of nonprofit websites, though an environmental charity would be the most obvious choice. But green is also appropriate for any charity that deals with new beginnings or growth. And the brown adds a sense of stability to the overall palette.

Red is associated with a number of medical charities already, and is well-suited for those types of websites. The addition of two shades of gray to an otherwise monochromatic palette makes it more dynamic.

Educational institution sites

The websites of educational institutions tend to stick to traditional color palettes. In most cases, educational sites need to appeal not just to those seeking to learn, but also to the parents or guardians of potential students.

This need to have broad appeal means that these types of websites need to stick to the tried and true, rather than experimenting with more fashionable color palettes. Common colors found on the websites of educational institutions include blue, red (and particularly maroon or burgundy), and green.

A blue and green color palette is fairly traditional in the world of educational institution websites. The addition of a warm gray adds some depth to the otherwise simple palette.

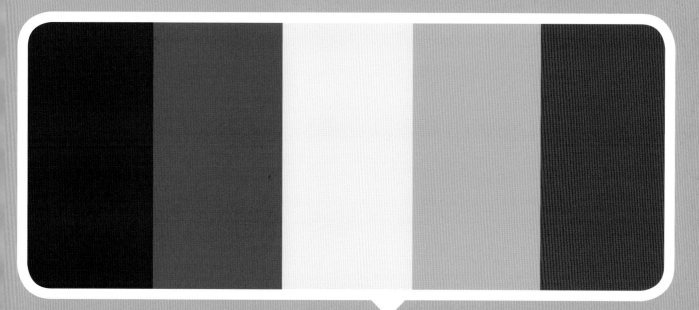

A red and steel gray color palette is also very traditional. Dark red is associated with willpower, leadership, and vigor, all positive attributes in an educational environment. The bluish gray adds a more conservative touch to the palette, as does the light gray.

Fashion sites

We often think of the fashion industry in terms of being bolder and more likely to take risks. And while that is true of the products themselves in many cases, it is not so true of the websites and other marketing materials.

Instead, most fashion industry sites tend to stick to neutral color palettes. This allows the emphasis to be squarely on the products, rather than the site design. While it is not true for every site out there, you will find that the majority of fashion industry websites serve as something of a blank canvas for whatever the company is selling.

The same is true of many fashion blogs and news sites, as well, from large magazine websites to individual daily fashion blogs. You will find that a lot of these sites have white backgrounds and neutral overall color palettes. This leaves the focus on the content.

Regardless of what industry the site you are designing falls into, keeping the purpose of that site in mind when creating your color palette is vital to the success of the overall design. Study the meanings of the colors you plan to use, including whether they have different meanings in different cultures within your target market, and then choose the colors that help reinforce the message you want to convey.

If your client is pushing for a palette that does not match the purpose of their site, don't be afraid to tell them the meanings behind those colors. It's your job as designer to steer them in the right direction, and color is no exception.

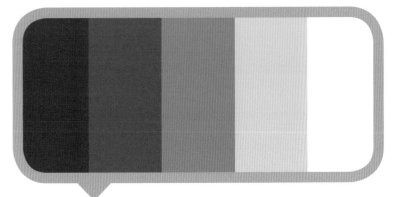

Green is a somewhat unexpected choice for a fashion site, especially in such a muted tone. But it would be an excellent option for a men's fashion site, as it really lets the site's content stand out more than a more saturated color would.

Pink is a much more traditional color palette for a women's fashion site. Light tints like these almost act as neutrals, though they have a bit more pop when combined with gray and white. This palette could contribute to a very feminine design.

using shades, tints, and tones

The use of shades, tints, and tones in your color palettes is necessary to create dynamic, interesting, visually pleasing designs. Pure colors quickly become overwhelming, and using exclusively tints or tones or shades can become boring quite quickly.

The key is to use all three in your palettes to create something unique and effective. How you combine them is largely

dependent on the overall purpose of your design and the message you want to convey. It is amazing what the addition of black, white, and gray to pure hues can do to the feeling of an individual color.

Over the following pages are some examples to show you just what is possible by altering the shades, tints, and tones of various pure hues.

Here is an example of a tone, tint, and shade that can be achieved from pure orange. The upper right is a 50% white tint. The lower left is a 50% black shade. And the lower right is a 50% gray tone.

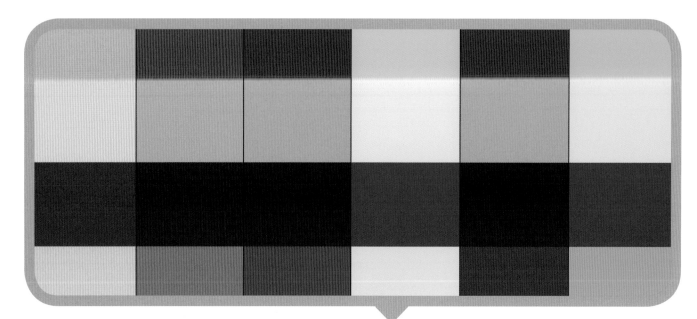

The pure, saturated version of this color palette (top row) doesn't work at all. There is no real improvement if we add 50% white (second row) or 50% black (third row) to the hues, either. It is still boring and bland, with a lack of contrast. But, if we combine tones, tints, and shades (bottom row), we can create an interesting, dynamic color palette with plenty of contrast. The orange becomes an almost-neutral cream color, while the reddish-pink hues become closer to neutral, too. The green, blue, and orange all stand out more when combined with the other hues.

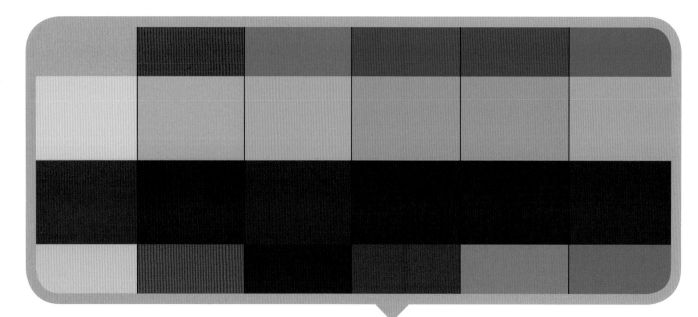

The pure hues (top row) in this palette work okay together, but there is not a whole lot of visual interest. The second row shows tints of each hue, which does make it all a bit more interesting. The shades in the third row, though, nearly all blend together, with very little contrast. By combining tints, shades, and tones in the bottom row, and even incorporating two colors that are close to their pure hues, we can create a very interesting palette.

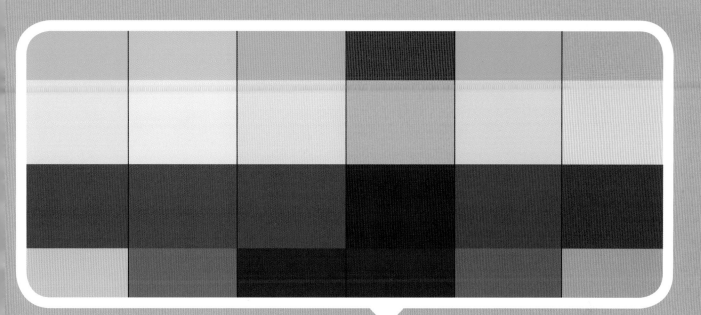

The fully saturated hues (top row) in this palette are lacking contrast. The same can be said for the tints (row two) and shades (row three). But again, the combination of tints, tones, and shades creates a lot of visual interest, even though there is nothing even resembling a pure hue in the bottom row of this palette.

The pure hues (top row) in this palette work pretty well together, and even have a reasonable amount of contrast. The tints of each (second row) could also make for a perfectly acceptable color palette. The shades of each hue (third row) would be less suited to a color palette on their own, though if they were combined with some of the tints, would work nicely. But, as with previous examples, the most pleasing palette is a combination of tones, tints, and shades.

balancing your color palette

Balance in your color palette is vital to creating a design that is balanced overall. But what is balance, in terms of color theory and color palettes?

Balance is largely dependent on how the colors within your palette interact with one another. Picture a color wheel that looks something like the one opposite.

To get a sense of how balance works, picture the color wheel balanced on a point at its center. Now, look at your design or your color palette and then imagine placing weights on various points around the color wheel, either on pure hues or tones, to represent how much they are used in the design. As you place them, you may see that your color palette is leaning in one direction or another.

Consider how placing weights at other points on the wheel could shift the balance.

Now, just because a site is not "balanced" in the traditional sense does not mean it does not work. That is where the concept of harmony comes in.

Harmony is another way of saying that two or more things "make sense" when combined. Harmony is more subjective than balance, because it has more to do with feeling and intuition than set rules.

This is where color theory gets really interesting. What has harmony for one person might not necessarily work for another. That's okay. The key is to get into the mind of your target market or your ideal visitor and figure out what would have harmony for them. What is going to appeal to them, and their aesthetic sensibilities?

That can be easier said than done. After all, a lot of the time people are not even consciously aware of the effects that color has on them. They don't know, because it's all happening behind the scenes. A memory here, an impression there, and before they have even processed what they're looking at, they've formed an idea of what your site's message is as well as their opinion of your site, product, and company (though nothing says that impression can't change later).

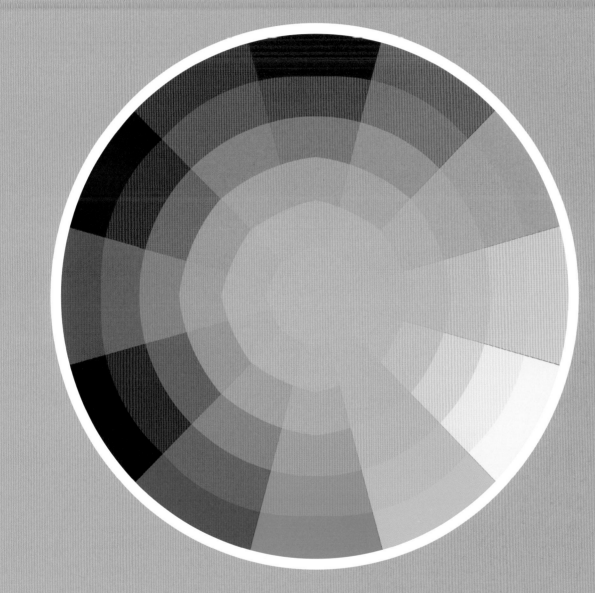

This color wheel shows a sampling
of different tones for each pure hue.

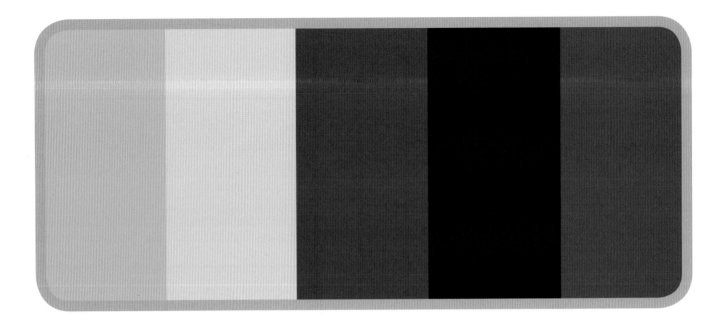

The good news is that there are a few things you can consider to get at least a general idea of what might convey the appropriate message and what might work in the eyes of your target audience. Once you have an image in your head, or a more formal persona for your ideal visitor, you can go ahead and answer these questions in terms of their likely opinions and values.

What cultural influences do they have? Earlier in this book, we discussed how different cultures and countries place different meanings on particular colors, sometimes in complete opposition to each other.

What similar product associations might they have? If everyone in your industry is using a shade of blue in their company branding, then acknowledge the impact that using or not using blue will have on your visitors. Can you use blue in a new and interesting way, for example?

What mood are you trying to create or what feeling are you trying to evoke? A website that wants to create a dynamic, energetic mood is going to need a completely different kind of harmony and balance to a site that is supposed to be relaxing and calming. In the first case, you might want to have a somewhat off-balanced color palette to create

a sense of movement. In the second, traditional balance might be more important, in addition to harmony.

Using neutrals to achieve balance

If your website color palette feels off-balance, then adding in a neutral can go a long way toward balancing it out, or at least making it feel harmonious.

For example, let's say that your color scheme is feeling very dark, and you want to lighten it up to keep it from being too heavy. White, of course, is the most obvious choice if you want to make something lighter.

But what if white is too cold or too harsh? Why not try adding a very subtle tone of one of your existing colors (an almost-neutral)? This keeps everything feeling very harmonious, while achieving your purpose.

The same can be done if you want to make your light color palette a little bolder. Rather than trying to add a bright color, try adding black or gray. Or for something even more unexpected, go with a shade of brown. Brown is a great neutral, as it adds warmth while also grounding your design. Brown is unexpected because it is not used nearly as often as gray or black.

In using neutrals and near-neutrals in your color palettes to achieve balance, you do have to be cautious not to let the neutrals overwhelm your chosen palette. They can do so, especially the stronger neutrals (like white and black). Remember that in implementing these colors, you may need to rethink the use and strength of other colors in your palette to maintain the right feeling and mood for the site.

A word about achieving balance through complements

The other way of creating balance, which has already been mentioned in this section, is through the addition of complementary colors to your palette. This, in effect, balances our imaginary color wheel.

The downside to this is that complementary color schemes can have a very powerful effect. Complementary color schemes almost always add a certain amount of energy and movement to a design, which can be undesirable in some cases. One way to avoid this, but still use complementary colors, is to use subtle tints, tones, and shades (depending on whether you want a light, dark, or muted color palette). This diminishes a lot of the movement, though some energy in that area will still exist.

This is why harmony is so important and should be focused on in addition to, or even instead of, balance. Sometimes balance just cannot be achieved while maintaining the overall mood of your site. Creating balance should not be at the expense of maintaining your site's purpose and appeal to your target audience. Doing so negates the entire reason behind creating a carefully thought out color palette.

When forced to choose between a site that is unbalanced but enhances the overall feeling of the site (and thereby is harmonious) and a site that has a balanced color palette but gives a conflicting psychological message, always go for the harmonious color palette.

6

CONVENTION IN WEB DESIGN COLOR THEORY

The conventions of color theory that already exist for web design are important to recognize. With a thorough understanding, you can decide when to stick to convention and when to deviate from it.

traditional color usage in web design

In virtually every design field, there are conventions that exist that set certain expectations on the part of the audience or target market of the design. For example, we assume that particular information will be found in the header or footer of a website, that navigation will appear in one of a couple places (header, sidebar, etc.), and so on. Or on an even more basic level, we expect that every website will have things like navigation and content.

The same is true in the world of color theory. Different industries have different conventions when it comes to color in design. This is partially determined by what color palettes the biggest and most successful companies or organizations have in each sector, and partially because of the meanings each color has. Of course, the two are not mutually exclusive, and generally the big companies in a particular industry chose their color palettes based on the meanings they convey, either consciously or subconsciously.

For example, corporate sites often use shades of navy blue, as blue conveys loyalty, honor, reliability, and trust. Sites in the environmental sector generally use shades of green, due to its strong associations with nature, but also because of its association with growth, freshness, and well-being. Sites catering to children often use bright colors, particularly primary colors, as studies have shown that children like bright, vibrant colors. All of these color choices are expected by the visitor, and give an immediate sense of familiarity, which can greatly improve the visitor's perception of the site and the brand. That sense of familiarity will put your visitors at ease, even if they've never visited your site or dealt with your company before.

industry conventions and standards

Every industry has certain colors that are associated with it. These colors are often chosen because of specific feelings they evoke and attributes they are given. But they can also be used based on tradition more than actual research into the colors themselves. And to an extent, the companies that use certain colors have influenced their meanings through association over the years. After all, when you see the color red now, how often do you think of Coca-Cola, Target, or the American Heart Association, and what those brands represent, rather than more traditional associations like lust or danger?

Unsurprisingly, there is a lot of overlap when it comes to colors used across industries. In fact, red and blue are the most commonly used colors in corporate branding across a number of industries. According to Emblemetic, which collects and interprets data about corporate logos, the beverage and hospitality industries use red most often in their corporate branding, while the insurance, chemical, medical, pharma, and telecom industries all use blue more often.

Green is also very popular in the chemical industry, and only second to blue. This could easily be due to its association with being environmentally friendly (an image that many companies in the chemical industry may struggle with, regardless of their actual environmental impact). Green is also associated with safety, which is also highly desirable in branding for a chemicals company.

Gold and purple, on the other hand, are unpopular regardless of industry, with orange and brown not far behind. Considering purple is a very unpopular color among men, its exclusion from most corporate brands makes sense. The other colors are not particularly visually striking (though orange, of course, can be), which also makes sense when considering branding.

associations based on popular sites and brands

In every industry there are leaders who set trends and create certain standards. Color is no different. Trendsetters in various industries can have a huge impact on what colors become the standard for that particular sector in terms of what consumers expect to see. Companies need to be cautious about choosing colors outside what is expected, as consumers can often have very negative reactions to those choices.

In the long term, colors used by certain companies or in certain industries can even have their meaning shift and change over time due to people's feelings about that particular company or industry. If controversy or scandal occurs around a brand with a very strong association with a particular color, then that color may become tainted by that particular scandal, either temporarily or even permanently (at least in the eyes of some). But the same is true of companies or organizations that do good things. For example, pink is strongly associated with breast cancer awareness (though it has long been associated with femininity), and little is going to change that in the immediate future, at least.

News sites

Blue is very popular on news sites, which makes sense considering its association with truth and honesty. After all, the primary purpose of most sites in this industry is to become a trusted source of information. Color goes a long way toward establishing that feeling, at least on a website visitor's initial impression.

Red is another popular color. This also makes sense for the news industry, considering red's connotations of power and authority. Both of those attributes are highly valued in the news and information industry, though it's a much more aggressive branding stance than blue.

MSN (www.msn.com)

MSN is one of the most popular websites on the internet, with more than hundreds of millions of unique visitors each month and billions of page views. Because of its broad reach across the web, MSN has kept their color palette very simple. The main colors are white and cyan, with other colors coming from images on the site. This simple palette puts the focus squarely on the content, though it doesn't create a very striking visual on its own.

CNN (www.cnn.com)

CNN is another very popular news site, associated with the cable network of the same name. The color palette for the CNN home page is close to monochromatic, using shades of red along with whites and grays. Other colors are used to replace the red on other parts of the site. For example, the business section of the site uses blue in place of red. On the home page, brightly colored section headers are used for subsections of the site.

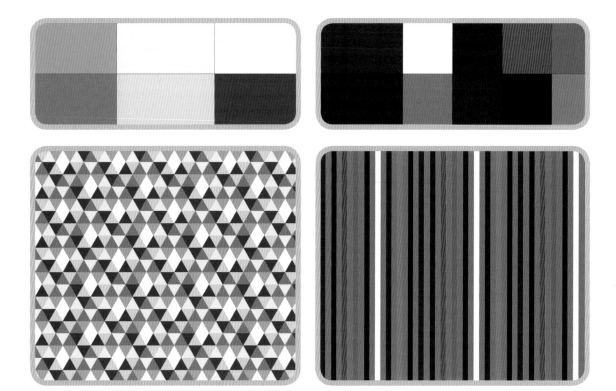

Today (www.today.com)

The Today Show's website is another very popular news website, associated with the morning news show. It uses a palette of orange, including a peachy tint and a brownish shade. It's a great example of how tints and shades of orange can act as neutrals, while creating plenty of visual interest.

Huffington Post (www.huffingtonpost.com)

The Huffington Post website uses different colors for each section of the site, with green being the primary color used for the site, including the home page. Colors used for other sections include blue, orange, purple, gray, green, and pink. The consistent style of the site makes the different color palettes in each section work well.

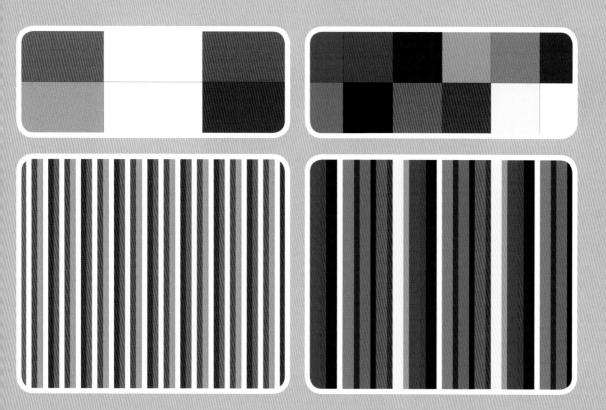

People Magazine (www.people.com)

People Magazine's website uses bright cyan, purple, and magenta against a background of white. This is perfectly suited to the target audience of the site, which is younger women. Dark shades of gray and black are also used throughout the site, giving it more depth and interest.

New York Times (www.nytimes.com)

The New York Times sticks to an incredibly basic color scheme, using nothing but white, black, and navy blue throughout the site. It's effective, and reminiscent of the site's newspaper roots. Accents in shades of light blue are occasionally used throughout the site as well.

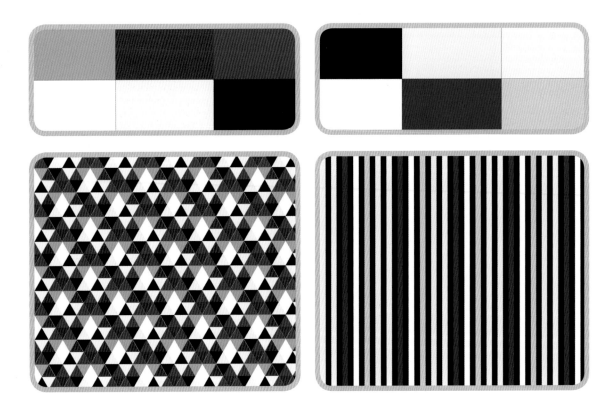

Software and app sites

The color palettes used by software and app websites are largely dependent on who the target market for those apps and software products is. In some cases, that target market is a fairly young demographic, in some cases it is a very specific demographic, and in others still, the demographic is quite broad. This can make developing a color palette particularly challenging, as it may need to appeal to a large, diverse audience, while at the same time being both appropriate to the product and unique enough to stand out from the competition.

Microsoft (www.microsoft.com)

Microsoft is one of the largest companies in the world, creating hardware as well as software. The Microsoft site uses a variety of bright colors, though overall it is unified by a strong, dark blue shade. This blue (or very similar variations) has been associated with Microsoft for years, giving the site a sense of consistency despite frequent updates to the design as products and trends change.

Adobe (www.adobe.com)

Adobe, the company behind Photoshop, Flash, and a multitude of other products, has a very simple color palette on their website, consisting primarily of shades of gray. A tone of blue is used for links throughout the site, as well as red (in the product logos) and yellow accents (in buttons and calls to action), which add some extra visual interest.

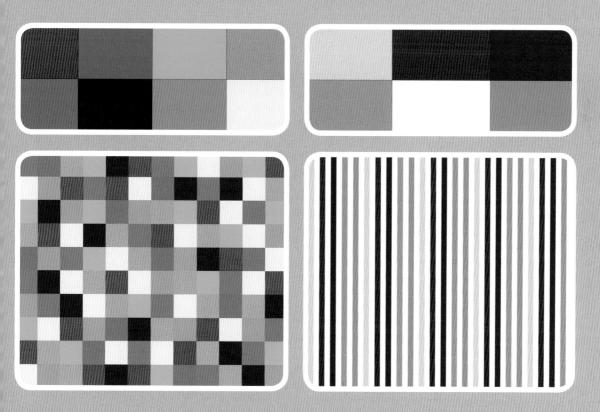

Windows (www.windows.com)

Like the Microsoft website, the Windows website makes use of lots of bright colors, particularly yellow, cyan, and magenta (the subtractive primary colors most often used in printing). It's a bright, fun color palette that draws lots of attention. It's perfect for targeting a younger, hipper audience, which makes sense considering their main competition (Apple).

Dropbox (www.dropbox.com)

The Dropbox website uses an almost monochromatic color scheme made up primarily of blues, with a green accent color used as well. It's a very soothing palette, especially since the colors are used sparingly against a white background.

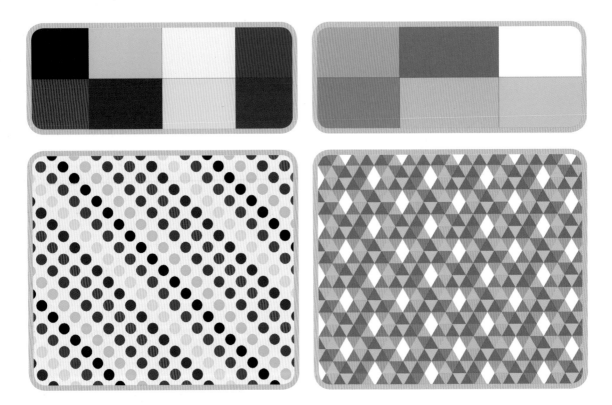

Mozilla (www.mozilla.com)

The Mozilla website has a very simple color palette, made up of blues, green, and gray. It's sophisticated and fresh, and works well with whatever graphics they opt to use on the site to promote their various projects and products.

Rovio (www.rovio.com)

Rovio, the maker of Angry Birds, Tiny Thief, and other games, has a fairly simple color scheme, made up mostly of shades of gray, placing the emphasis squarely on the graphics promoting their games. Accent colors used on the site include yellow and red, though they're used sparingly.

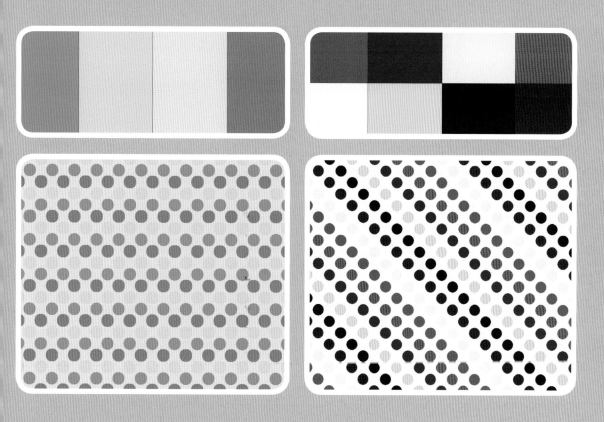

Financial sites

Green and blue are both very popular colors on financial sites. Green is associated with money, which obviously makes sense in this industry. It's also associated with growth, which again is good. Blue, on the other hand, is closely tied to reliability, loyalty, and honesty, all of which are valuable qualities in a financial institution. Both colors fall in the cool end of the color spectrum, which makes sense considering we generally like to associate "cool-headedness" with those responsible for managing our money.

Granted, not every financial site is going to use these industry-standard colors. In fact, some branch out in an entirely different direction, which is unexpected but very visually interesting. And it sets those sites apart from their competition in a very powerful way.

Bankrate (www.bankrate.com)

Bankrate offers information about various financial products, including mortgages, credit cards, money market accounts, and more. Their website uses a fairly predictable blue and white color scheme, typical of financial and corporate websites. The use of yellow as an accent color works well, giving a bit more visual interest than the straight blue color palette would on its own.

Chase Bank (www.chase.com)

Chase opts for a brighter blue color palette than many other financial websites. It gives the site a younger, fresher look, which is further enhanced by the green accents used on buttons throughout the site.

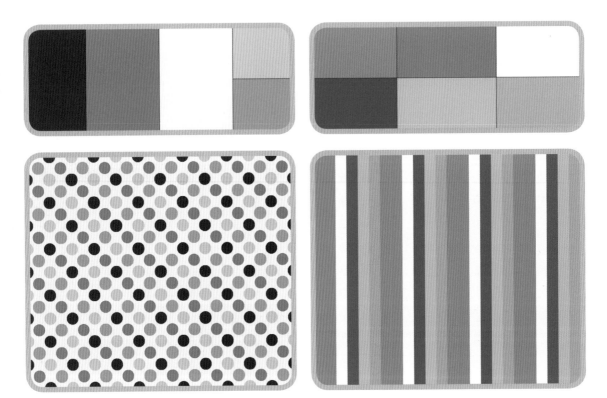

Wells Fargo (www.wellsfargo.com)

Wells Fargo takes a very different approach to color selection than most other financial institutions. Rather than sticking with the predictable and industry-standard blues and greens, they've branched out with a mostly purple and orange color palette. It's a fresh and unexpected decision, and works beautifully.

American Express (www.americanexpress.com)

The American Express website uses shades of blue and gray for the bulk of its color palette. As with many other financial institution websites, yellow buttons are also implemented for a bit of extra visual interest.

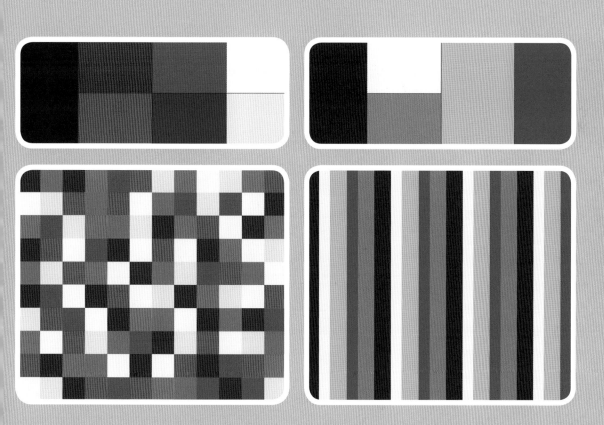

Entertainment sites

Bright colors are common on entertainment sites, with blue, yellow, green, and red being particularly popular. These saturated, primary colors draw a lot of attention, but are used in very limited quantities on most of these sites, with the bulk of each palette made up of neutrals. This, of course, leaves the focus on the content, much of which is very visually oriented.

IMDB (www.imdb.com)
IMDB, the Internet Movie Database, uses a color palette of primarily grays, with some gold and blue typography. The use of gold in this color palette is reminiscent of film awards like the Academy Awards and the Golden Globes, which makes a lot of sense in this context. The sophisticated grays further reinforce this feeling.

Netflix (www.netflix.com)
Netflix uses a primarily red color palette, with a light gray base color and dark gray accents. It's a very strong use of color, and is associated with Netflix as well as certain other online video sites.

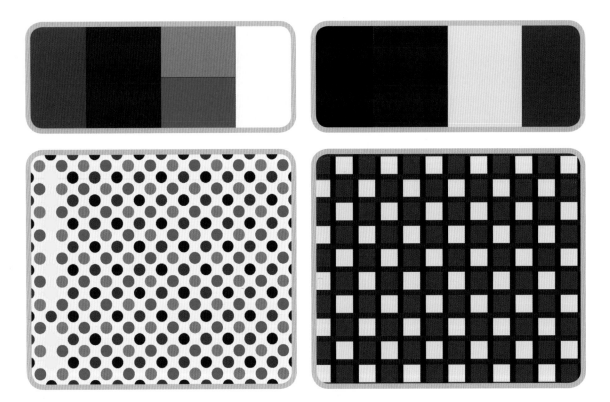

Hulu (www.hulu.com)

Hulu's website uses a mostly neutral palette consisting of shades of gray, along with lime green accents. This works well considering the bold graphics associated with the programming on their site, allowing the content to take center stage.

YouTube (www.youtube.com)

YouTube has a mostly white and gray color palette, with red accents and blue links and buttons. The mostly neutral palette allows the site's content to shine through.

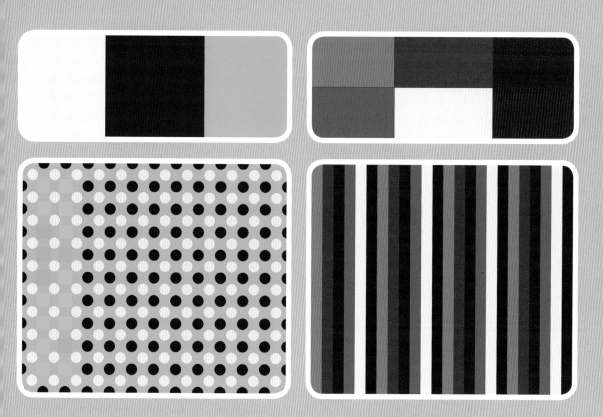

Home and garden sites

Most, though not all, home and garden sites have women as their primary target audience. Even traditionally more "male" companies in this sector, such as hardware stores, have realized that women are actually a major consumer of this type of product. At the same time, plenty of men also peruse a lot of these sites, which means they need to have a palette that appeals to both sexes. Not every site does this, of course, but many of them do.

As far as which colors are most popular, green is commonly seen, but it's by no means a definitive front runner in this industry. Instead, it's normal to see a variety of colors on these sites. The one thing they have in common is that bright colors used in limited amounts seem to be the standard.

Brit + Co. (www.brit.co)

The Brit + Co. website uses white and shades of gray for the base colors, with bright accent colors used for each section. The bright colors really stand out against the neutral background, adding a very fun feeling to the site.

Better Homes and Gardens (www.bhg.com)

The BHG website uses a color palette of white and gray, with shades and tints of green as the main colors, and a dark teal for an accent color. The greens work well to evoke a "garden" feeling, while the teal provides interest without too much contrast.

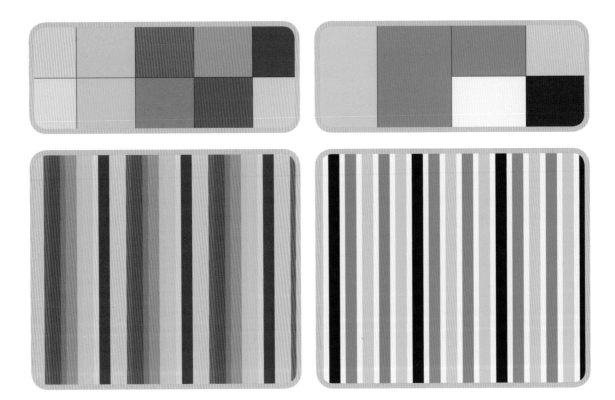

Martha Stewart (www.marthastewart.com)

Leave it to Martha Stewart Living Omnimedia to create a site with an inventive color palette. While the site initially appears to have a mostly gray color palette, in fact the palette is made up of tones of brown alongside gray, with lime green accents. It's sophisticated without being stuffy.

Home Depot (www.homedepot.com)

Home Depot has made orange synonymous with home improvement. On their website, they combine orange with gray and white for a very simple, but effective, color palette.

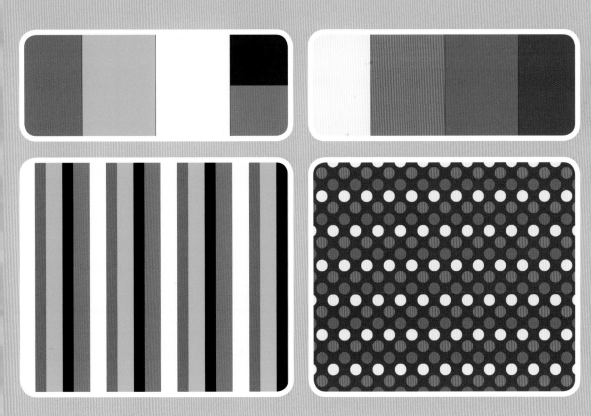

Environmental and eco-friendly sites

It's unsurprising that green is the most popular color in the palettes of environmental sites. That being said, not every eco-friendly website adheres to a green-based palette. Other popular colors include brown, due to its associations with nature, obviously, as well as shades of gray.

Light or bright blue are sometimes seen on eco-friendly sites, too. This is largely due to their associations with water, which is also very fitting for a site about the environment and associated industries.

Treehugger (www.treehugger.com)
Brown, tan, and green make up the bulk of the Treehugger color palette. Both green and brown evoke the earth, making them perfectly suitable for an environmental news site like Treehugger.

Grist (www.grist.org)
Grist takes an alternative approach to eco-friendly design, without a trace of green to be found. Instead, they use orange, black, white, and gray in their color palette. It's an unexpected use of color, giving it a bold visual style that sets it apart from others in the industry.

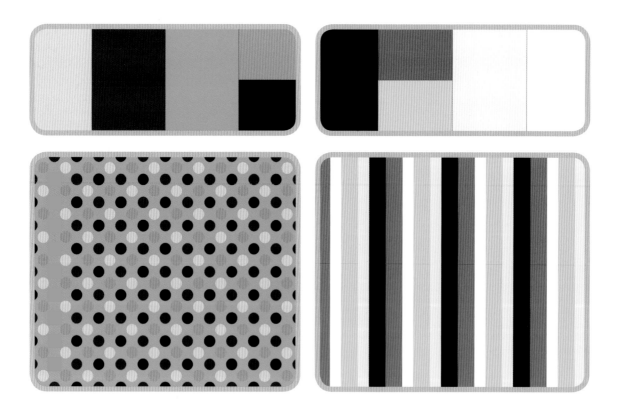

Ecorazzi (www.ecorazzi.com)

Ecorazzi, which covers celebrity environmental news, uses a color palette of orange, brown, and green, which fits perfectly with their eco-friendly content. Since brown is just a shade of orange, the use of the two colors together gives a very harmonious look to the overall palette.

Celsias (www.celsias.com)

The Celsias website uses a palette of bright green, cyan, and gray. The green is an obvious choice, while the cyan evokes water, which is a less-often-used, but still very appropriate choice.

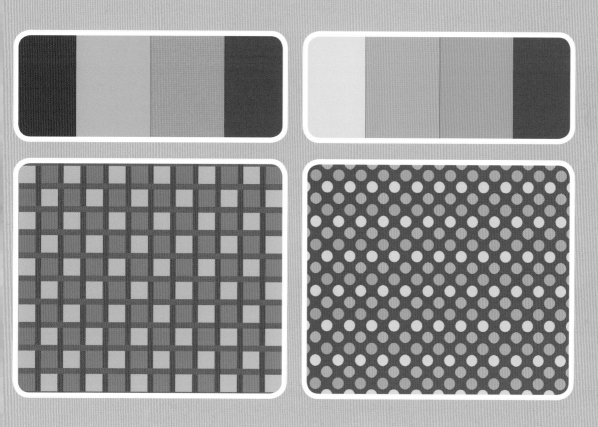

E-commerce and shopping sites

You'd think that with the diversity of online shopping sites and the products they sell, there would be very little consistency in their color palettes. While this is true to an extent, one thing that you'll see across most sites is a very simple, basic palette that allows the products for sale to really shine through and take center stage. Even when bright main and accent colors feature, they're often used in very limited quantities, which can give them a big impact.

Most online retailers fit their color palette to whoever their target market is. Rather than looking at the site in relation to it being an e-commerce site, as a designer you should look at it in terms of the industry the products fall in instead.

IKEA (www.ikea.com)
IKEA, the Swedish furniture retailer, uses a very basic color palette on their site, largely made up of white, black, and dark gray. But the menus, typography, and links on the site are done in blue and orange, which adds visual interest without taking away from the products, which remain front-and-center.

Target (www.target.com)
Target's website uses the familiar red and white color palette associated with all of the retailer's branding. Besides that, they use blue for their links, as well as shades of gray for typography throughout the site.

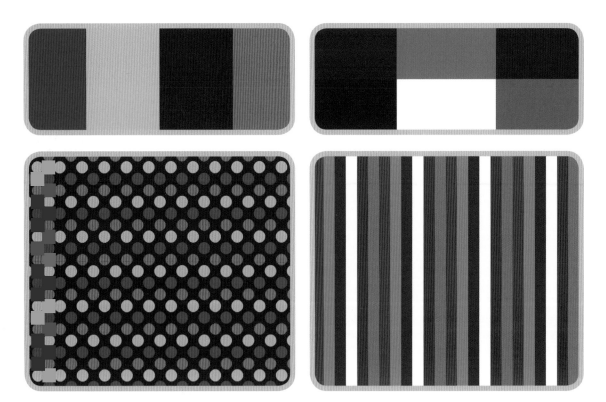

Walmart (www.walmart.com)

Walmart's site color palette matches the store's branding, making use of royal blue and a couple of golden orange hues, along with shades of gray. The orange hues have a very positive connotation, and are associated with sunlight. The blue hues inspire loyalty and trust, both of which are vital to the success of any e-commerce site.

Groupon (www.groupon.com)

Groupon, the coupon and discount site, uses green as a base color, which makes sense considering its strong associations with money. Cyan is used as an accent color, providing sufficient contrast with the green, while shades of gray make up the rest of the color palette.

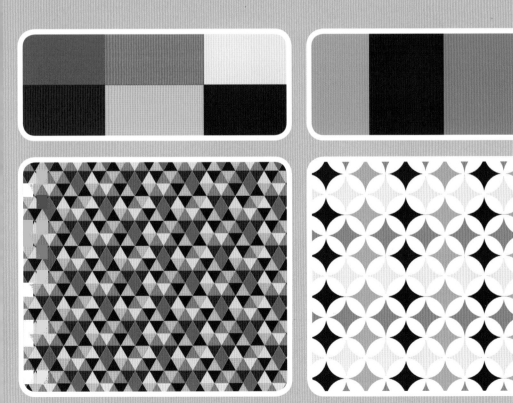

Travel sites

Across the travel industry, blue is an incredibly popular color, regardless of what the specific site or company is. Granted, the specific shade or tint changes between sites, but it's rare to find a travel site that doesn't use some kind of blue somewhere in the design.

Besides blue, it's common to see other bright colors used in these types of sites. Because of their association with positivity and fun, it makes sense that travel sites would use these kinds of colors in their palettes. After all, many people booking or researching travel online are doing so for vacations. And even those who are booking for business or other travel are often thinking about their next vacation, so the color palette is still very applicable.

Travelocity (www.travelocity.com)

Travelocity's main color used throughout the website is blue. A light tan is used as the base color throughout, while orange, lime green, and additional shades and tints of blue are used as accents on buttons, section backgrounds, and in the typography.

Expedia (www.expedia.com)

Expedia has a very strong color palette, made up of yellow and blue with a white base color. Yellow is reminiscent of the sun, which evokes positive feelings, while blue inspires a sense of trust. These are both excellent choices for a travel site, as they're both likely to improve the mood of anyone booking a vacation.

Orbitz (www.orbitz.com)

Orbitz uses a variety of blues as their main colors, with magenta and green as accent colors against a white base color. Magenta and green are both playful and positive, which makes sense for a travel site. The blue implies trustworthiness and loyalty.

Virtual Tourist (www.virtualtourist.com)

Virtual Tourist is a travel review site with a simple but sophisticated color palette. Black and shades of gray are used as base and main colors, while blue and magenta are used as accent colors. It's a fun palette, perfect for this type of site.

personality is more important than industry

While it's important that you understand which colors are popular in any industry in which you are designing a website, the personality of the organization or company that the site is for is ultimately the most important thing.

For example, let's say you're designing a website for a law firm. Tradition might dictate that you use a dark, subdued color like navy blue since it evokes trustworthiness, loyalty, and responsibility. But let's consider taking it in a different direction. Let's say this law firm specializes in divorce and family law, and they want to avoid a heavy color palette that could be considered depressing. Green, particularly light or bright green, is associated with new beginnings, rebirth, and growth, and is a generally positive color without being too warm. Creating a color palette based around a green main color, with something like navy blue for an accent color, and a subtle neutral for a base, establishes an appropriate feeling for the law firm's site, while still being fresh and unexpected.

Sit down with your creative team or your client and discuss adjectives that describe the organization you're designing for. Talk about who the target market is and the feeling you want them to have when they visit the site. Consider the color palettes being used by others in the same industry or targeting the same market, and then decide whether you want to stick with what's already been established or branch out into something different.

There are other advantages to choosing a color that is not similar to those used by your competition. For one, if you use a color in the same family of hues as your closest (or biggest) competitor, then you may be seen as an impersonator, rather than your own unique brand with your own benefits. You'll be seen as an inferior product or service, and you'll be starting from a disadvantage.

For example, in the social networking sphere, virtually every major site (Twitter, Tumblr, Facebook, LinkedIn, etc.) uses a shade or tint of blue as their primary branding color, and blue is used extensively throughout their website color palettes. Blue is not going to set any site apart in this sphere. But using a different color, like orange or green, could make any new competitors stand out.

A mellow green tone is an unexpected, yet highly appropriate, color choice for a law firm. The navy accent color puts the palette more in line with what's expected on this type of site, appealing to more traditional visitors.

While a thorough working knowledge of color theory is a good basis, you need to know how to apply that knowledge in order for it to be of any real use—and that's exactly what this section aims to teach you.

professional color use in your designs

Having read to this point, you'll hopefully have established a thorough working knowledge of how color works. You know what terms are commonly used in reference to color theory, and you know how others have combined colors to create palettes for their websites. And you've seen the trends in a number of major industries and how they implement color on their own websites.

But how does that all translate into creating your own color palettes for your designs? How do you take all of this theoretical knowledge and apply it in the real world, to real projects? This goes beyond just how to physically combine colors. This is getting into the more refined art of how to create appropriate color palettes for your particular project. That's a much more difficult and challenging task than just creating a palette. But it can also be a very rewarding aspect of the design process.

Should you start with the design or the palette? That's often a very troubling question for a lot of designers, even those with years of experience. But that's because most designers, and most people even, think of color and design as two separate—albeit linked—entities, when they're really integral to one another. Trying to divorce color and design is really impossible. A good design can suffer greatly from a poor choice of color, while a beautiful color palette can't save a horrible design (though it might make it a little less horrible).

Consider the personal associations you might have with a particular color palette, too. Memories, both conscious and subconscious, can have a very profound effect on our perception of color and what it means to us. Sit down with the others on your design team, or on your client's creative team, and discuss what personal associations each team member might have with the colors you're considering.

While color meanings and the feelings different hues evoke is largely personal in many instances, associations one person makes are likely to be shared by others, even if they're not universally recognized associations. Shared experiences and common cultural influences (particularly from popular culture) can have an impact before they're widely recognized as meanings or associations with a certain hue.

For example, you might associate a dark golden yellow with sunflowers. But a new parent might associate it with changing their newborn's diaper. Not exactly the same image now, is it? And it's not going to evoke the same kinds of feelings by any means.

Now, whether or not to use that dark golden yellow in your design is going to depend on your target market. If you're designing a site aimed at gardeners, then the sunflower link is going to be much more prominent. But if it's a site selling high-end baby clothes, the association may be less welcome. After all, you don't want your potential customers to be picturing your beautiful white layette sets covered in baby mess!

The solution is often simple, though. Making that dark golden yellow brighter or lighter can remove the potentially negative connotations, and have it once again associated with flowers. So carefully consider what your target market is going to think when they see your color scheme. Just

because established "facts" about universal color meanings say one thing does not mean that every individual, or even every group, is going to have the same take on it.

Having discussions about these associations will undoubtedly lead to a stronger color palette in your final design.

This also goes to show how important context is in terms of your color palette choices. Red, for example, can be tied closely to love or anger, and the type of site you're using it for will have a direct impact on how your visitor perceives it.

working within conventions

We've already discussed some of the conventions in color theory among different industries and niches. During the discovery and research phase of your projects, you should examine what your client's closest competitors are doing in terms of color. Study the colors they use for their backgrounds, typography, and graphical elements. Look at the color hex codes in their stylesheets to see exactly which colors they're using (searching for the hash symbol within their stylesheets can speed up this process, though of course that's not foolproof if the designer failed to use hashes to precede their hex codes).

If you decide to work within the conventions already established in your site's industry or niche, you need to think about how to differentiate your design from its competitors in the same space, especially any industry leaders. If every site in an established niche with high competition is using red, then you need to work toward finding a shade or color combination that will be unique from the other sites in that sector, or you risk getting lost in the shuffle.

Let's say, for example, that you're designing a website for a company in the financial sector, specifically one that has created a new personal budgeting application. In this particular niche, green and blue are very popular colors.

In most of the color palettes for these kinds of sites, bright blue and bright or light green are used most prominently. So for your particular website design project, you might opt to use a muted sage green along with a dark steel blue as the basis of your color palette. This sets your design apart from its competitors, while still maintaining the status quo among potential users, who have come to expect a certain thing in that type of site.

You could expand that basic two-color palette by adding additional shades of blue and green.

Make a list of the colors (with their hex codes, if possible) that are used on the top five or ten sites in your niche, and look for the patterns and the prominent hues. Then, consider how you can adapt those by mixing them with a little of one of their analogous colors to change their base hue a bit, or how to create a tint, tone, or shade of the same color to make it unique.

breaking with tradition

Now, just because a certain set of colors are most commonly used in a particular industry doesn't mean that you can't break free of those traditions and do something entirely different. Companies do this all the time, and while it's not the "safe" option like maintaining the status quo, it can pay big dividends by really setting your design apart from the competition.

If you do decide you want to break from what's already been established in your niche, you'll need to carefully consider why the already established colors are used. What feelings do these colors evoke? What do they say about the companies in this particular industry?

Once you have answers to these questions, you can decide whether those same feelings and impressions are what you want your own target audience to have. If so, then consider which other colors can evoke those feelings and impressions. If not, consider which colors do evoke the appropriate responses.

For example, if we use the same personal budgeting app industry as mentioned before, we know that the established colors are blue and green. Blue is associated with loyalty, honesty, and reliability, among other attributes. Green is most obviously associated with money, but is also tied closely to self-reliance and growth. Obviously, these are all things that have positive connotations within the personal finance sector.

But let's consider what other colors might imply in the same sphere.

Red can be discounted almost immediately, as it is too closely tied to negative bank balances and being "in the red." That's not exactly what you want your potential users to think of when they see your product.

Orange is better, as it's tied to optimism. But on the flip side, it can also be tied to superficiality. Not necessarily what you want your app to be associated with.

Yellow has similar positive connotations to orange, and is also associated with the mind and intellect. It could be an excellent choice for a financial site.

Purple is a very creative color, but can also be considered mysterious. It's not the worst choice to be used for a financial site, but it's not exactly the best choice either.

Turquoise is often associated with communication, as well as idealism. This might be a good choice for a social finance app, or one that's focused on goal-setting and achievement.

Brown could be a surprisingly good choice for a finance site, as it's tied closely to stability, security, and material wealth. It's also rarely used in this sector, which means it could be a fantastic choice if you want to break with tradition.

A combination of brown and turquoise would be an excellent, unexpected choice that would work very well for a personal finance app site. Turquoise combines the blue and green already established in the industry while still breaking from the "norm," while brown implies stability and wealth, which is obviously an excellent choice for this particular industry.

choosing a place to start

At this point you have a lot of research on which colors might be appropriate for your design. Next up is choosing one (or more) of them to start creating a palette for your website. To an extent, you can do this somewhat randomly. As in, pick a hue to start with, and then start making adjustments until you're happy with what you have.

Alternatively, you can look for existing palettes with similar colors to what you'd like to use for inspiration. There are a number of color palette sites online that you can start with. My personal favorite is design-seeds.com, though there are a multitude of other options out there.

Once you have a color or two to start with, you can branch out using one of the traditional color scheme patterns already discussed earlier in this book. From there, you'll need to make adjustments to each hue, adding white, black, or gray to change the intensity, brightness, and saturation of each to create a palette that's pleasing to the eye.

balancing your color palettes

Balancing your color palette is more art than science. Established rules and traditional color schemes will only get you so far. From there, you'll need to trust your eye to create the most visually appealing, balanced, and harmonious color palette that works for your project.

We've already discussed balance in previous chapters, but now let's look at some examples. We'll start with our green and blue palette for a personal finance site as mentioned before.

First we'll come up with our sage color and our steel blue color. From there, we can create tints, shades, and tones of each to come up with the other colors in our palette. A light green acts as a sort of neutral in the palette, as does the very dark blue. The brighter sage could be used as an accent color.

Next we'll create a palette based on our turquoise and brown hues, for something a bit different from the standard blue and green color scheme in the personal finance app niche.

Once you have the basic turquoise and brown shades picked out, you can expand on these with tints, shades, and tones of each. Remember that brown is actually a shade of orange, which means we could easily incorporate orange as an additional accent color within the palette.

Opposite we can see that the dark turquoise and the light cream color both act as neutrals along with the brown. The bright orange and turquoise can both be used as main or accent colors.

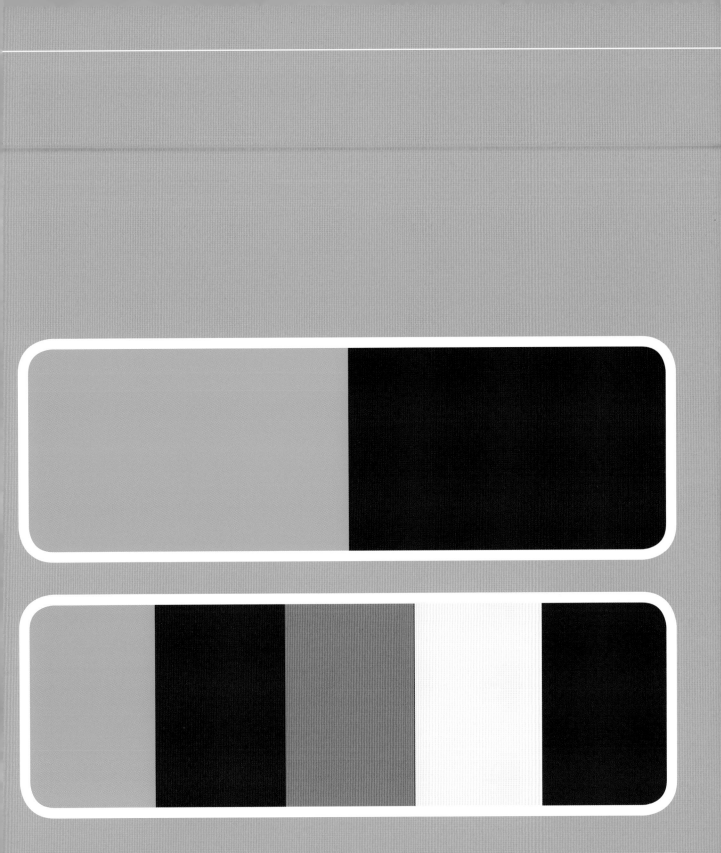

using almost-neutrals

Almost-neutrals, also sometimes called quasi-neutrals, are colors that aren't achromatic (like most true neutrals, with the exception of brown and tan) but are optically very close to it. They can be shades, tints, or tones, and can be made from any pure hue.

As seen above, each of these almost-neutrals looks like a shade of gray. These can be an excellent way of making your design's color palette a little warmer or a little cooler without making drastic changes. Instead of choosing to use a pure black, white, or gray, consider using an almost-neutral in the same hue family, or in an analogous or complementary hue, depending on the effect you're going for.

Adding an almost-neutral tint of yellow to a site with a largely gray and blue palette will make the palette appear warmer. Or adding an almost-neutral shade of green to a primarily red palette will cool the palette off just a bit.

These are really subtle ways to change the feeling and tone of your designs without making drastic changes to your palette. This can also be a great way to unify a palette that isn't otherwise particularly harmonious. Sometimes our clients require us to use certain hues due to corporate branding guidelines that have already been established. Adding an analogous or complementary almost-neutral color to the scheme can unify otherwise disparate colors.

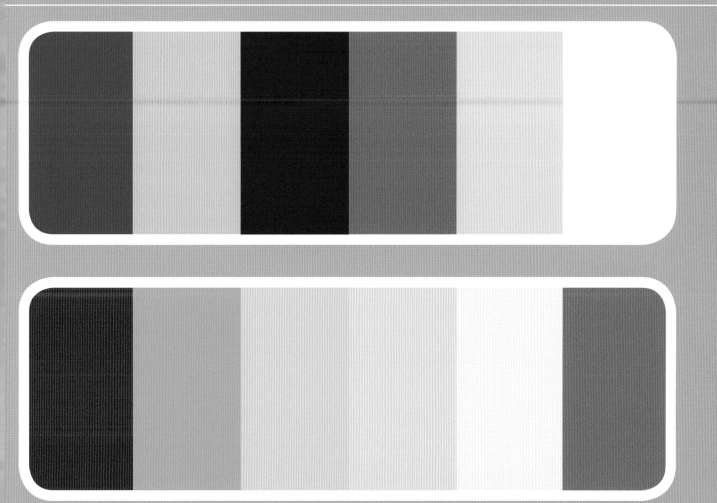

color, meet responsive design

Until a few years ago, designers only had to create one version of a website, because websites were only viewed on one type of device: a computer (either desktop or laptop). But with the rise of the mobile web, designs need to adapt to all sorts of devices, from smartphones to tablets to desktop computers.

While your color palette won't necessarily change for these differing designs, you may find it necessary to simplify how your colors are used on smaller screens. Contrast important here, especially when it comes to typography, as oftentimes a visitor might be viewing your site in less-than-ideal conditions (like bright sunlight).

There's no hard-and-fast rule, but be sure to test your color palettes in the design on a number of devices and in a variety of environments.

the importance of user testing

Regardless of whether you decide to stay within the conventions established within the industry you're designing for, the importance of user testing cannot be stressed enough. While asking the opinions of your creative team about the colors you select can give you a good idea of what your target demographic is likely to think, it's not foolproof.

Getting the opinions of real visitors on the colors used on your website, as well as studying the results when different color palettes are implemented simultaneously, can give you much better insight into the real effect color can have on your site's success. Sometimes even changing the color of a single button can create a huge difference in your response rate.

There are two main ways to test your color scheme. The first is to use an A/B test. This is when you only change a single variable on your site. For example, changing the color of your call to action buttons. It's recommended that your call to action buttons be set in a color that contrasts with the rest of your website, even if you might think the

color to be inappropriate. For example, if your site's color palette is primarily made up of warm pinks and oranges, a call to action button in green or blue might get much better results than one in simply a different shade of orange or pink. And of course the opposite is true also: if your site is mostly blues and greens, a red call to action button might get you fantastic results, even though you may initially associate red with "stop" or danger.

The alternative to A/B tests is multivariate testing, where you test multiple changes at once. This is a good option if you want to test two completely different color palettes (possibly along with other changes to the design).

Some designers may opt to start with multivariate testing, and then proceed to A/B testing for refining their color palette (and other aspects of their design).

The important thing here is that you test your color palette, along with other aspects of your site's user interface.

a few final words on color

Color theory is a mix of science and art. There are rules, for sure. There are traditions and customs, some of which are universal, while others vary greatly depending upon culture. What represents purity and life in one culture may represent ill intentions and death in another. This is why it is vital to understand the cultural perceptions of color in your target market, especially if that market is different to your own.

A color that means one thing to one person can mean something entirely different to another person, even one with a similar cultural and national background. That's because personal experience is so intrinsically tied to how we perceive color. Both positive and negative experiences can impact how we view color and what it means to us.

In other words, you cannot expect that a color palette you create for a website is going to mean the same thing to every person who views that website. What you can do, however, is work in generalizations. You can get a good idea of what effect a color palette will have by studying both traditional meanings and discussing it with your creative team.

This is also where user testing comes in handy. Ask those performing user-interface and user-experience tests questions that will give you their feelings on color. And observe their behavior when presented with differences in color palettes in your design, as this can be far more telling than what a user consciously thinks about your use of color.

Don't expect to become a color expert overnight. It's part art and part science, and while you can master the science aspects of it in a methodical way, the artistic aspects of color theory take more time to develop, and are best figured out through trial and error. Take time to study the color palettes of others, as well as experiment with your own. Try out different color palettes on the same design, to see just how much impact it can have on your perceptions of the design.

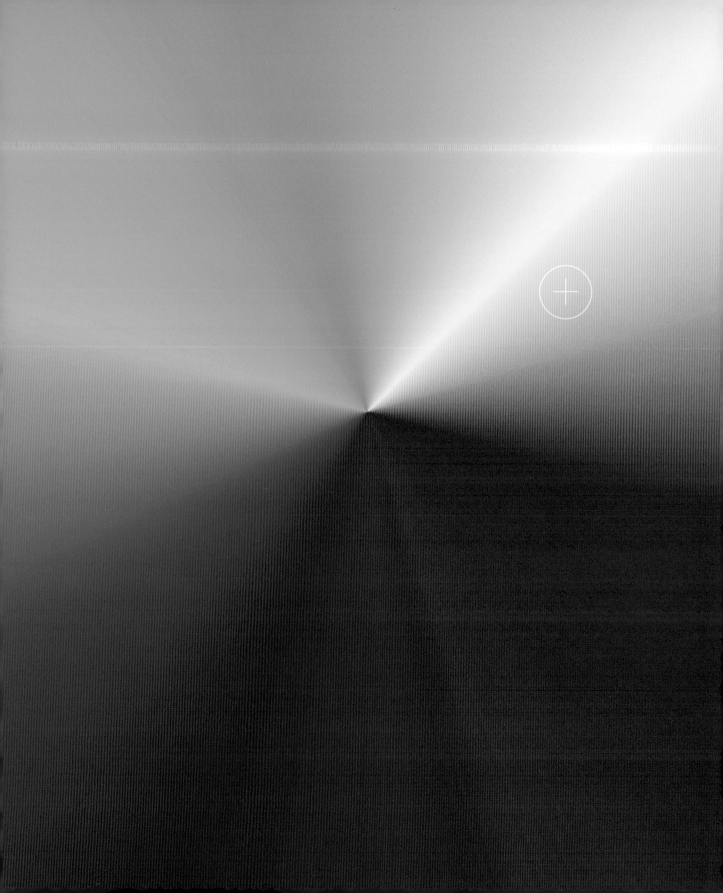

8

REFERENCES

Here you'll find additional tools that can make creating color palettes a lot easier, as well as a checklist to guide you through the design process. And as a bonus, there's also a complete illustrated case study detailing the process in the real world.

case study

design brief

Company: Little Bird Vintage

Company background: Little Bird Vintage is both a brick-and-mortar and online vintage clothing and accessories retailer, specializing in feminine and quirky pieces. Their customers are mostly 20- and 30-something women who are well-educated and interested in art, music, and crafting.

Web assets needed: A website and accompanying banner for their Etsy storefront. They wanted a unified image for both.

the process

The mood and feeling of the brand were already revealed somewhat in the design brief: quirky and feminine. The colors for the website should also be fun, whimsical, and carefree. And of course, since it's an e-commerce site, the colors needed to give a sense of trust.

Dark colors, jewel tones, and the like would be inappropriate for this kind of site. Bright colors might be appropriate, as might pastels. A combination of the two, with dark gray or black typography, would be very appropriate.

Once it had been established that the main colors should be bright or pastel, specific colors could be chosen to use as a starting point. We started with five colors, as it gave plenty of choices without being an overwhelming number. These colors were:

Dark teal: #60A8A1

Antique yellow: #F0D07F

Pale blue: #B4D4CF

Purple: #994583

Bright coral: #F27154

All five of these colors fitted into the general feeling we wanted to express with the color palette.

Next we created a traditional scheme for each. To add to the quirky and fun feeling of the site, we wanted to stay away from monochromatic schemes, and go for something with more diversity. We started with a triadic scheme for each one, though you could also start with a split-complementary or square scheme. To make things quicker and easier at this stage, use an app like Adobe Kuler to create these schemes. These gave us a jumping-off point for creating our final palette.

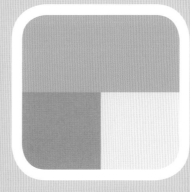

Our dark teal combined with purple and yellow.

Antique yellow combined with a bright cyan and purple.

Our pale blue was teamed up with bright lavender and a yellowish gray.

The purple hue combined with bright cyan and a grayish olive hue.

And our bright coral combined with a royal blue and a bright lime green.

Next we saw what each one looked like as a double-complementary scheme. It added even more potential interest and contrast to what would be our final palette.

Our dark teal matched up with a soft blue, yellow, and peach.

Antique yellow combined with a bright yellow, purple, and blue-violet.

Our pale blue teamed up with soft green, beige, and pale yellow.

The purple hue combined with a raspberry and two grass greens.

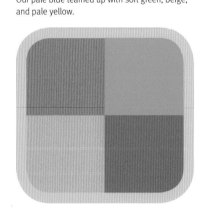

And our bright coral combined with blue, a dark goldenrod hue, and an almost-pure green.

While those schemes all provided a lot of contrast, we also considered an analogous scheme for yet another option.

Our dark teal paired with soft blues and greens.

Antique yellow combined with bright yellow, and muted olive, brown, and peach hues.

Our pale blue teamed up with pale lavender, blue, and greens.

The purple hue combined with maroons and brighter purples.

And our bright coral combined with golden yellow, olive, brown, and fuchsia.

The main idea here is to explore your colors and how they interact with other hues. It's a jumping-off point, intended to inspire additional ideas and lead the way to the final color palette.

From here, we focused on just one or two of the colors for the final palette. After getting feedback from other members of the design team and getting some input from the client, we settled on the bright coral (#F27154) and the pale blue (#B4D4CF). These hues are quite different, but they offer up plenty of possibilities. The client liked the vibrancy of the coral, and saw a lot of possibilities in the pale blue, though felt it needed to be combined with some brighter hues to "amp things up."

Based on the site mockups, we knew we needed five colors beyond the black and white base hues (which were primarily being used for the site's typography): four main hues and an accent hue. Ideally, the accent hue needed to be bright and saturated, while the three main hues should be of varying intensities and saturation levels. Here's the basic site mockup:

LITTLE BIRD VINTAGE

Lorem ipsum dolor sit amet, consectetur adipisicing elit, sed do eiusmod tempor incididunt ut labore et dolore magna aliqua. Ut enim ad minim veniam, quis nostrud exercitation ullamco laboris nisi ut aliquip ex ea commodo consequat. Duis aute irure dolor in reprehenderit in voluptate velit esse cillum dolore eu fugiat nulla pariatur. Ex-

Lorem ipsum dolor sit amet, consectetur adipisicing elit, sed do eiusmod tempor incididunt ut labore et dolore magna aliqua. Ut enim ad minim veniam, quis nostrud exercitation ullamco laboris

Lorem ipsum dolor sit amet, consectetur adipisicing elit, sed do eiusmod tempor incididunt ut labore et dolore magna aliqua. Ut enim ad minim veniam, quis nostrud exercitation ullamco laboris

Lorem ipsum dolor sit amet, consectetur adipisicing elit, sed do eiusmod tempor incididunt ut labore et dolore magna aliqua. Ut enim ad minim veniam, quis nostrud exercitation ullamco laboris

Lorem ipsum dolor sit amet, consectetur adipisicing elit, sed do eiusmod tempor incididunt ut labore et dolore magna aliqua. Ut enim ad minim veniam, quis nostrud exercitation ullamco laboris

Lorem ipsum dolor sit amet, consectetur adipisicing elit, sed do eiusmod tempor incididunt ut labore et dolore magna aliqua. Ut enim ad minim veniam, quis nostrud exercitation ullamco laboris

Lorem ipsum dolor sit amet, consectetur adipisicing elit, sed do eiusmod tempor incididunt ut labore et dolore magna aliqua. Ut enim ad minim veniam, quis nostrud exercitation ullamco laboris

Lorem ipsum dolor sit amet, consectetur adipisicing elit, sed do eiusmod tempor incididunt ut labore et dolore magna aliqua. Ut enim ad minim veniam, quis nostrud exercitation ullamco laboris

Lorem ipsum dolor sit amet, consectetur adipisicing elit, sed do eiusmod tempor incididunt ut labore et dolore magna aliqua. Ut enim ad minim veniam, quis nostrud exercitation ullamco laboris

After further discussion, we decided to use the analogous color schemes as the basis of our palette. Obviously, there wasn't enough contrast between the five hues here, as they're all very similar in saturation and intensity. So we adjusted the brightness and tone of each to get more diversity.

Our pale blue was now combined with light and dark greens and a dark marine blue for our main hues, with a brighter blue as an accent. It's a very appealing palette, but wasn't quite right for our project.

Our bright coral combineed with tan, dark taupe, brown, and light pink. There's definitely something lacking in this palette.

These were a step in the right direction, but they were not quite there yet. We saw what we could do with each before deciding on our final palette.

The pale blue palette was quite attractive, but it didn't really pop. The bright blue was a nice accent, but wasn't enough. We needed something that would really stand out. So we pulled a pink from the split-complementary color scheme.

The main issue with the coral color palette was that it was pretty boring. The coral was dragged down by the other hues, and the light pink clashed with the rest. So we pulled in some colors from the split-complementary scheme to spice things up a bit. We pulled in the blue and lime green, but adjusted their intensity. We were now using a very light tint of the lime green and a very muted tone of the blue. It was a vast improvement over the original palette.

We tried each of these palettes in our mockup,
and then made any final adjustments and a decision.

LITTLE BIRD VINTAGE

Lorem ipsum dolor sit amet, con-
sectetur adipisicing elit, sed do eius-
mod tempor incididunt ut labore et
dolore magna aliqua. Ut enim ad
minim veniam, quis nostrud exerci-
tation ullamco laboris nisi ut
aliquip ex ea commodo consequat.
Duis aute irure dolor in reprehen-
derit in voluptate velit esse cillum
dolore eu fugiat nulla pariatur. Ex-

Lorem ipsum dolor sit amet,
consectetur adipisicing elit,
sed do eiusmod tempor incidi-
dunt ut labore et dolore
magna aliqua. Ut enim ad
minim veniam, quis nostrud
exercitation ullamco laboris

Lorem ipsum dolor sit amet,
consectetur adipisicing elit,
sed do eiusmod tempor incidi-
dunt ut labore et dolore
magna aliqua. Ut enim ad
minim veniam, quis nostrud
exercitation ullamco laboris

Lorem ipsum dolor sit amet,
consectetur adipisicing elit,
sed do eiusmod tempor incidi-
dunt ut labore et dolore
magna aliqua. Ut enim ad
minim veniam, quis nostrud
exercitation ullamco laboris

Lorem ipsum dolor sit amet,
consectetur adipisicing elit,
sed do eiusmod tempor incidi-
dunt ut labore et dolore
magna aliqua. Ut enim ad
minim veniam, quis nostrud
exercitation ullamco laboris

Lorem ipsum dolor sit amet,
consectetur adipisicing elit,
sed do eiusmod tempor incidi-
dunt ut labore et dolore
magna aliqua. Ut enim ad
minim veniam, quis nostrud
exercitation ullamco laboris

Lorem ipsum dolor sit amet,
consectetur adipisicing elit,
sed do eiusmod tempor incidi-
dunt ut labore et dolore
magna aliqua. Ut enim ad
minim veniam, quis nostrud
exercitation ullamco laboris

Lorem ipsum dolor sit amet,
consectetur adipisicing elit,
sed do eiusmod tempor incidi-
dunt ut labore et dolore
magna aliqua. Ut enim ad
minim veniam, quis nostrud
exercitation ullamco laboris

Lorem ipsum dolor sit amet,
consectetur adipisicing elit,
sed do eiusmod tempor incidi-
dunt ut labore et dolore
magna aliqua. Ut enim ad
minim veniam, quis nostrud
exercitation ullamco laboris

The issue with the coral color palette once it had been put into the mockup was that it was a very
masculine palette, which didn't work at all for our site.

We scrapped that one and went to work on the other palette instead.

Here's where you can turn back to your various sources of inspiration to find some new ideas that will really make your color palette pop. Sites that let you search for palettes by hue (like Design Seeds, COLOURlovers, and Adobe Kuler) are a great place to start. We checked out some palettes on all three sites, and decided to make some adjustments to both the colors used and how we used them.

LITTLE BIRD VINTAGE

Lorem ipsum dolor sit amet, consectetur adipisicing elit, sed do eiusmod tempor incididunt ut labore et dolore magna aliqua. Ut enim ad minim veniam, quis nostrud exercitation ullamco laboris nisi ut aliquip ex ea commodo consequat. Duis aute irure dolor in reprehenderit in voluptate velit esse cillum dolore eu fugiat nulla pariatur. Ex-

Lorem ipsum dolor sit amet, consectetur adipisicing elit, sed do eiusmod tempor incididunt ut labore et dolore magna aliqua. Ut enim ad minim veniam, quis nostrud exercitation ullamco laboris

Lorem ipsum dolor sit amet, consectetur adipisicing elit, sed do eiusmod tempor incididunt ut labore et dolore magna aliqua. Ut enim ad minim veniam, quis nostrud exercitation ullamco laboris

Lorem ipsum dolor sit amet, consectetur adipisicing elit, sed do eiusmod tempor incididunt ut labore et dolore magna aliqua. Ut enim ad minim veniam, quis nostrud exercitation ullamco laboris

Lorem ipsum dolor sit amet, consectetur adipisicing elit, sed do eiusmod tempor incididunt ut labore et dolore magna aliqua. Ut enim ad minim veniam, quis nostrud exercitation ullamco laboris

Lorem ipsum dolor sit amet, consectetur adipisicing elit, sed do eiusmod tempor incididunt ut labore et dolore magna aliqua. Ut enim ad minim veniam, quis nostrud exercitation ullamco laboris

Lorem ipsum dolor sit amet, consectetur adipisicing elit, sed do eiusmod tempor incididunt ut labore et dolore magna aliqua. Ut enim ad minim veniam, quis nostrud exercitation ullamco laboris

Lorem ipsum dolor sit amet, consectetur adipisicing elit, sed do eiusmod tempor incididunt ut labore et dolore magna aliqua. Ut enim ad minim veniam, quis nostrud exercitation ullamco laboris

Lorem ipsum dolor sit amet, consectetur adipisicing elit, sed do eiusmod tempor incididunt ut labore et dolore magna aliqua. Ut enim ad minim veniam, quis nostrud exercitation ullamco laboris

After studying some other palettes, we came up with a few different iterations to try. First of all, we decided to go a bit more blue in the overall color scheme, and tone down the greens. And we toned down the darkest blue at the same time. This made the accent hue pop a lot more. At the same time, we changed the accent color to a more reddish hue, more along the lines of a raspberry color.

It was a vast improvement, but still wasn't quite right. So we decided to try a different accent color, and in the process, diversified the overall color palette quite a bit more by pulling back in a bright green and then adding back in our raspberry hue. The end result was interesting and fit the original purpose of the site, which was something quirky and fun.

LITTLE BIRD VINTAGE

Lorem ipsum dolor sit amet, consectetur adipisicing elit, sed do eiusmod tempor incididunt ut labore et dolore magna aliqua. Ut enim ad minim veniam, quis nostrud exercitation ullamco laboris nisi ut aliquip ex ea commodo consequat. Duis aute irure dolor in reprehenderit in voluptate velit esse cillum dolore eu fugiat nulla pariatur. Ex-

Lorem ipsum dolor sit amet, consectetur adipisicing elit, sed do eiusmod tempor incididunt ut labore et dolore magna aliqua. Ut enim ad minim veniam, quis nostrud exercitation ullamco laboris

Lorem ipsum dolor sit amet, consectetur adipisicing elit, sed do eiusmod tempor incididunt ut labore et dolore magna aliqua. Ut enim ad minim veniam, quis nostrud exercitation ullamco laboris

Lorem ipsum dolor sit amet, consectetur adipisicing elit, sed do eiusmod tempor incididunt ut labore et dolore magna aliqua. Ut enim ad minim veniam, quis nostrud exercitation ullamco laboris

Lorem ipsum dolor sit amet, consectetur adipisicing elit, sed do eiusmod tempor incididunt ut labore et dolore magna aliqua. Ut enim ad minim veniam, quis nostrud exercitation ullamco laboris

Lorem ipsum dolor sit amet, consectetur adipisicing elit, sed do eiusmod tempor incididunt ut labore et dolore magna aliqua. Ut enim ad minim veniam, quis nostrud exercitation ullamco laboris

Lorem ipsum dolor sit amet, consectetur adipisicing elit, sed do eiusmod tempor incididunt ut labore et dolore magna aliqua. Ut enim ad minim veniam, quis nostrud exercitation ullamco laboris

Lorem ipsum dolor sit amet, consectetur adipisicing elit, sed do eiusmod tempor incididunt ut labore et dolore magna aliqua. Ut enim ad minim veniam, quis nostrud exercitation ullamco laboris

Lorem ipsum dolor sit amet, consectetur adipisicing elit, sed do eiusmod tempor incididunt ut labore et dolore magna aliqua. Ut enim ad minim veniam, quis nostrud exercitation ullamco laboris

Note that the final design actually has a significantly different feel than the original mockup due to the use of color, while still retaining the functionality of that layout. Also notice that we included a pattern in the center two sections of the design to offset and highlight those areas. The addition of subtle patterns to a block of color can make a theme that feels rather "blah" into something much more interesting.

The second you look at the palette, you can just "feel" that it's right, and that it works. The process of getting to it wasn't streamlined, and wasn't straightforward, which is reflective of the process of designing a color palette in the real world. It's a process of trial-and-error, with what we hope will be a beautiful end result. The great thing about this palette is that it works so well with the culture of the company that it can be used for the life of the business, even if the website design changes at a later date.

Here's our final palette, which ended up with five hues, beyond white and black.

12 steps to creating a color palette

1 Determine the mood and feeling that the final design needs to have. Make a list of descriptive words and phrases that fit this mood and feeling.

2 Eliminate color options that directly contradict that mood or feeling, even if you want to do something unexpected and unconventional. You may also want to eliminate sets of colors, such as "jewel tones," "pure hues," or "pastels."

3 Choose colors that appeal to you and your client. If you're drawing a blank, look for inspiration from other websites, designs, or images, or even your surroundings.

4 Create a series of schemes based on traditional patterns as a jumping off point for developing your final palette.

5 Make adjustments to the colors in the schemes to create base, main, and accent colors in your palettes.

6 Don't be afraid to play around with unexpected additions to your palettes if you need to add interest or make them "pop" more, especially with your accent colors.

7 Consider creating a mood board for your palettes to further explore how the colors work together and interact with one another.

8 Choose your final color palette based on client feedback and any other considerations specific to the project.

9 Don't forget to add neutrals like black, white, and gray to your palette to round out your design options.

10 Create mockups of the final design using the colors you've selected. At this point, you may need to make adjustments to your specific colors to make sure there is sufficient contrast and that the colors are appropriate.

11 To make your design easier to maintain and develop, create a color style guide with the hex codes for each color and what they're used for. A great place to put this is as a comment at the top of your main CSS file, so that it's handy for future reference.

12 Don't forget to get approvals at appropriate intervals along the way. Your specific project and the decision-makers involved will dictate these intervals.

resources

accessibility tools

Check My Colours: http://www.checkmycolours.com
Check My Colours lets you check the foreground and
background color combinations of DOM (Document Object
Model) elements in any URL to see if they have adequate
contrast when viewed by someone who has vision deficits
in regards to color.

**WebAIM Color Contrast Checker:
http://webaim.org/resources/contrastchecker**
The WebAIM Color Contrast Checker checks the contrast
between two colors you enter, and lets you lighten or darken
the given colors until you find a pair with sufficient contrast.

**WCAG Contrast Checker: https://addons.mozilla.org/
en-us/firefox/addon/wcag-contrast-checker**
WCAG Contrast Checker is a Mozilla Firefox add-on that lets
you check the contrast levels, brightness, and shine of your
background and foreground text elements to see if they
comply with Web Content Accessibility Guidelines versions
1 and 2, from the W3C's Web Accessibility Initiative.

Contrast-A: http://www.dasplankton.de/ContrastA
Contrast-A is another web-based tool for checking the
contrast between foreground and background colors
for accessibility purposes.

color inspiration

Design Seeds: http://design-seeds.com
Design Seeds is a regularly updated collection of color
palettes pulled from images. You can search by color value
or by theme (such as "vintage," "summer," or "nature"),
browse palettes with similar colors, and easily share the
palettes you like on Facebook, Twitter, StumbleUpon, and
Pinterest, or via email.

Designspiration Color Search: http://designspiration.net
Designspiration's color search feature makes it easy to find
examples of designs using specific colors, based on their hex
value. It's fantastic if you're looking for ideas for how other
designers have used a particular color in their designs.

The Perfect Palette: http://www.theperfectpalette.com
The Perfect Palette is a blog that offers up color inspiration
on a regular basis, with photos illustrating the palettes.

Color Collective: http://color-collective.blogspot.com
Color Collective is a blog that features palettes taken
from images and the work of artists, designers, and
other creatives.

palette design tools

Adobe Kuler: https://kuler.adobe.com
Leave it to Adobe to create one of the best color selection and palette design tools out there. Kuler lets you create a variety of palettes based on traditional scheme rules, including analogous, monochromatic, complementary, and more.

Pretty IP: http://prettyip.meetstrange.com
Pretty IP is a fun place to start if you're looking for some inspiration. It will create a four-color palette based on your IP address. While it's not necessarily a palette you'll use, it could be a jumping-off point.

Color Explorer: http://www.colorexplorer.com
Color Explorer lets you create palettes quickly and easily, including palettes based on images. It's free to use, and also lets you browse color libraries from a variety of sources.

COLOURlovers: http://www.colourlovers.com
COLOURlovers is an entire community based around color, with lots of ideas to inspire you and the ability to browse both palettes and patterns.

Pictaculous: http://www.pictaculous.com
Just upload a photo and Pictaculous will generate a palette to use with it.

Colr.org: http://www.colr.org
Colr.org makes it easy to pull a color palette from an image. Just load your image, or choose a random image provided for you from Flickr, and when you hover over it you'll get a selection of colors to pick from.

ColRD: http://colrd.com
ColRD offers a host of tools for creating color palettes, either from scratch or from an image. It also has tools for creating patterns, gradients, and more.

Color Hunter: http://www.colorhunter.com
Color Hunter lets you create and find color palettes from images.

Color Scheme Designer: http://colorschemedesigner.com
Color Scheme Designer lets you create a palette based on traditional scheme patterns, and will even let you preview a website design mockup using the color palette you've created.

index

acknowledgments

A lot of people work behind the scenes on a book like this, and I'd like to thank all of them. But specifically, I'd like to thank the editors I've worked with: Ellie Wilson, Nick Jones, and Zara Larcombe.

I'd also like to thank all of the editors I've worked with at various blogs over the years, particularly Pete Cashmore of Mashable, who gave me my first paid blogging gig; Vitaly Friedman at Smashing Magazine, who was responsible for publishing my first color theory article series; and Walter Apai at Webdesigner Depot, for being so understanding of my crazy schedule when I have to meet print deadlines.

And finally I'd like to thank the huge network of writers who have helped me during my career, but especially Dan Holloway, who has offered unwavering support for my work since the beginning.

picture credits

Page 15: Knar Bedian: www.flickr.com/photos/9070031 N03/4609697710/

Page 16: Horian Varlan: www.flickr.com/photos/10361931 N06/5269820328/

Page 29: Viktor Hanacek: (top) picjumbo.com/healthy-potato-salad/; (bottom) picjumbo.com/bumble-bee-on-the-sunflower/

Page 33: Viktor Hanacek: picjumbo.com/sunflowers-field/

Page 34: Viktor Hanacek: picjumbo.com/tulips-from-below/

Page 35: J and R Photography: www.flickr.com/photos/34096260 N06/3320084584/

Page 38: Viktor Hanacek: picjumbo.com/airbag-mark-on-a-dashboard/

Page 41: Viktor Hanacek: picjumbo.com/another-yummy-muffins/

Page 42: Barney Moss: www.flickr.com/photos barneymoss/7889846226/

Page 43: MacKay Savage: www.flickr.com/photos mckaysavage/5102220415/

Page 44: (top) Akuppa John Wigham: www.flickr.com photos/90664717@N00/424497689/ (bottom) Andrew Currie: www.flickr.com/photos andrewcurrie/4113977791/

Page 45: (top) I A Walsh: www.flickr.com/photos ivanwalsh/4120034444/ (bottom) Stuart Caie: www.flickr.com/photos kyz/2733622280/

Page 46: particlem: www.flickr.com/photos particlem/2466310898/

Page 47: Shriram Rajagopalan: www.flickr.com/photos xenocrates/6785975569/